Digital Decorating

DESIGNS AND PROJECTS
FROM YOUR HOME COMPUTER

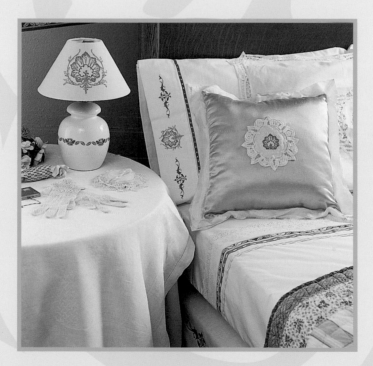

Tami D. Peterson

Martingale
& C O M P A N Y
Bothell, Washington

CREDITS

President . . . Nancy J. Martin
CEO . . . Daniel J. Martin
Publisher . . . Jane Hamada
Editorial Director . . . Mary V. Green
Editorial Project Manager . . . Tina Cook
Design and Production Manager . . . Stan Green
Technical Editor . . . Candie Frankel
Copy Editor . . . Liz McGehee
Photographer . . . Brent Kane
Cover & Text Designer . . . Rohani Design

Digital Decorating: Designs and Projects from
Your Home Computer © 2001 by Tami D. Peterson

Martingale & Company
PO Box 118
Bothell, WA 98041-0118 USA
www.martingale-pub.com

Printed in Hong Kong
06 05 04 03 02 01 6 5 4 3 2 1

Library of Congress Cataloging-in-Publication Data

Peterson, Tami D.
Digital decorating: designs and projects from your home computer/ Tami D. Peterson.
 p. cm.
ISBN 1-56477-354-X
1. Computer art. 2. Handicraft—Data processing. 3. Color computer printers. 4. Interior decoration. I. Title.

TT869.5.P48 2001 00-051128

DEDICATION
To Steve and Jamie, my heaven and earth

ACKNOWLEDGMENTS
Love and special thanks to Mom for everything, from us all; and to
Bob, Marlene, and Mike for your contributions and sacrifices along the way.
And thanks, a lot, Leo LaPorte. My appearance during the premiere
week of your *Call for Help* show caused this Digital Decorating
bug to hit me a few days later. I haven't been able to shake it since.

Contents

Welcome

The author in her studio

MOST BED-AND-BREAKFAST GUEST ROOMS have it. Country inns, with rare exception, have it. Homes featured in design magazines definitely have it. What is it? Some say it's a certain *je ne sais quoi*. But even this perfect French phrase for describing the indescribable boils down to "I don't know what."

Well, I do know what. And I'll show you the same remarkable, innovative techniques I've used in my home, to ensure that your home has "it" too. At a modest cost, your abode can exude style, charm, and unparalleled personal distinction. All of which will cause your friends and guests to utter another set of wondrous words: "How did you do that?"

With your computer, that's how! It's a concept I call Digital Decorating. You'll be amazed at the projects you can create—from wallpaper borders to decorator tiles to printed linens—using a PC, a color inkjet printer, and a few simple-to-use software programs. With Digital Decorating, you don't have to be a natural-born decorator or even a computer whiz, for that matter. A beginner who has never used a PC can do the Digital Decorating projects in this book. If your computer skills are rusty, never fear. After all, having a mission in mind when you first face a blank computer screen is the best way to learn. My years of training others to use PCs taught me that.

Once you've completed your first Digital Decorating project, I'm convinced you'll be eager to try all of the projects presented here, and more. Don't be surprised, either, if you discover that your Digital Decorating studio isn't complete without a color scanner, a digital camera, and specialty printer papers. (For more on everything you'll need and want, see "Digital Decorating Tools" on pages 8–15.) Digital Decorating is more than projects; it's a way of life. A rather stylish one, I might add.

So stop showcasing the computer in your home—use it to showcase your home! Now join me, won't you, in my Digital Decorating salon.

How to Use This Book

THIS BOOK IS DIVIDED INTO TWO PARTS. Part 1 will fill you in on the basic Digital Decorating tools and supplies you'll need, introduce the techniques I've developed, and answer your questions. I hope it will become a guide you can turn to again and again for information and inspiration. In Part 2, you'll find more than forty individual projects for the entire house, room by room. Think of each project in a generic way, and remember that *you* need to supply the theme, colors, and artwork to suit your lifestyle and decor. That's the whole point of Digital Decorating.

Each project begins with a list of materials. It's a given that you will be using a computer, software, and printer for every project, so I've omitted these items from the materials lists unless a specific type is needed. If the project requires special printer capabilities, such as banner mode or wide-carriage printing, the materials list will note it.

You'll also need paper for printing. I like to leave the choice of paper up to you, so unless a particular medium is required, such as inkjet decal sheets for adorning ceramic tiles, I've left paper off the materials lists, too.

The project instructions assume that you possess some basic do-it-yourself skills and that you feel comfortable using your computer and printer. I won't be teaching you how to paint furniture or operate your iron; likewise, when I say "mirror-print your image," I'm assuming you know how to do that using your particular computer software. Page-layout and graphics-editing software programs from various manufacturers may differ slightly in their features, tool sets, and interfaces, but they all have the same basic functionality. My instructions are geared to the common thread among them. Besides, it simply wouldn't be feasible for me to spell out individual directions for the dozens of software packages on the market.

If you discover that your computer skills are lacking, there are plenty of resources available to help you. "Sources and Credits" (page 92) lists the names, phone numbers, and Web addresses of popular manufacturers of the hardware and software used in Digital Decorating. If they can't help you directly, they can refer you to learning centers and consultants in your area.

Just as you might improvise in following a cooking recipe, I encourage you to look for ways to improve or adapt my ideas and methods as you go, and possibly to develop some new techniques of your own! The intent of Digital Decorating is to expand the home-decor choices available to all of us. The projects on the pages that follow should get you off to a fashionable start.

Part 1
The Basics

Digital Decorating Tools

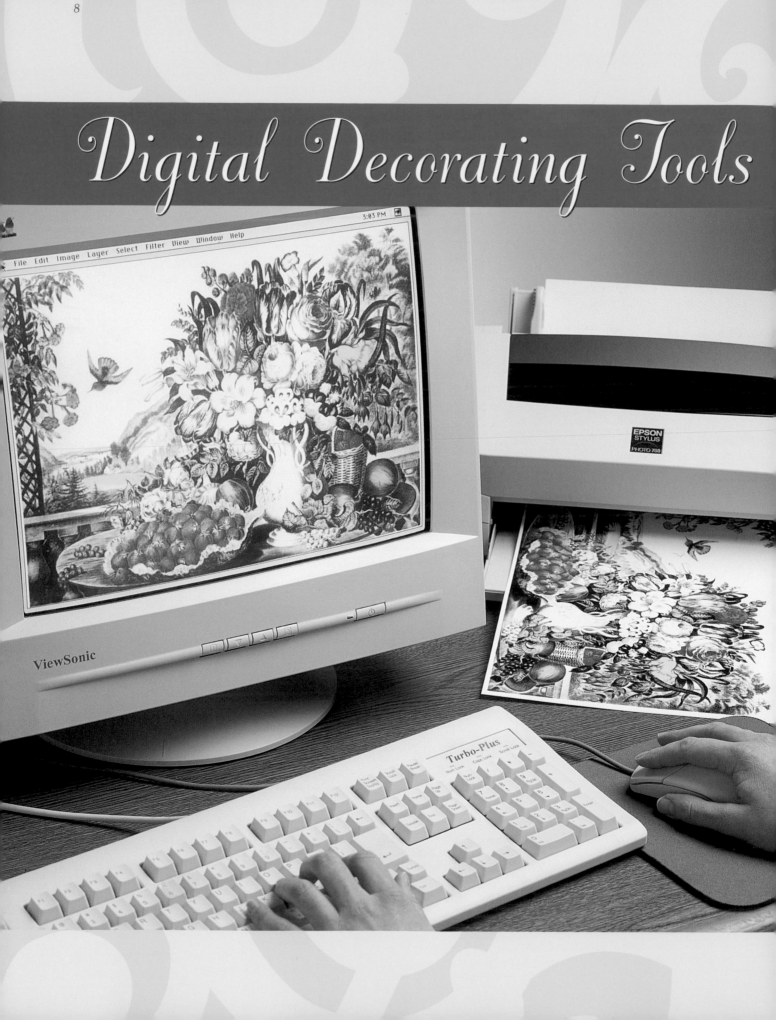

THE TOOLS FOR DIGITAL DECORATING, from sophisticated computer equipment to garden-variety craft supplies, say a lot about the art itself. For years, computer makers have been trying to get consumers to think of PCs as home appliances. When used for Digital Decorating, they are finally just that: as vital to the busy household as a microwave, with the same down-home functionality of a sewing machine or ironing board. Digital Decorating is not about making things look high-tech or futuristic. Rather, it's about utilizing your computer in ways never used before, getting beyond Net surfing, e-mail, and games, and truly discovering and benefiting from the "personal" in PC.

Chances are you've never even thought about making your own wallpaper border. We're talking a border that you have personally selected, colorized exactly to your home's decor, and proportioned perfectly to the dimensions of your room. Once you see how simple it is, you're bound to become hooked on this and other Digital Decorating techniques. You may find you've got more use for a computer than anyone else in your home, and your family will be clamoring to buy another. When that happens, make sure you claim the new one and leave the hand-me-down for the Net surfers and game players. You've got better things to do with a PC!

HARDWARE

Your primary tool for Digital Decorating is, of course, a computer. You don't need to rush out and buy the latest processor, but you do want a reasonably fast machine, equipped with as much memory and hard-drive storage as your budget allows. The graphics programs and files you'll be using are resource-intensive.

Whether you prefer a Macintosh system or a Windows-based PC is up to you; equally useful software for Digital Decorating is available for either. I consider any late-model PC with 128 megabytes of RAM and 10 gigabytes of disk space a minimum, though you can get by with less to start. You must have a CD-ROM drive, but its speed is not a significant factor. When deciding where to invest additional money at the onset of a Digital Decorating PC purchase, always opt for a bigger hard drive, then more memory, followed by a larger monitor. After those features, a faster processor and a speedier CD-ROM drive are helpful additions.

With a well-outfitted computer at your disposal, your next must-have piece of hardware is an inkjet printer. Fortunately, this is one of the least expensive purchases you'll make. Suitable models regularly sell for around $100. Since inkjet printers are among the most heavily discounted of all peripherals, you'll find some models cost less than $50 after rebates and special promotions. Be sure to check out the Web sites of the major printer manufacturers (see "Sources and Credits" on page 92) for reconditioned models, many with limited warranties, sold at direct discounts.

While all of the projects in this book can be done using an ordinary small-carriage inkjet printer, I did make a few using a wide-carriage inkjet printer and/or a sublimated dye–equipped printer. These tools expand the possibilities for creating original home furnishings, but you don't need to jump into them right away—your small-carriage inkjet printer is perfect for getting started. Color thermal and color laser printers can also be used, but because their ink systems are different from inkjet printers, you'll need to familiarize yourself with their unique characteristics and paper support before attempting the Digital Decorating methods exactly as I teach them in this book.

Knowing what to buy next is mostly a matter of personal choice, since you can do so much with just an entry-level inkjet printer. For many people, a scanner is a more practical next investment than a wide-bed printer. A flatbed scanner will let you add family photos, pictures, and other scannable art to your work. You might also consider a digital camera. You will save on film and developing costs and can use your images as soon as they're snapped, without the interim step of scanning. As you develop your Digital Decorating skills, you can always invest in new and more versatile tools, much the way you'd add a specialty sewing machine, embossing tool, or laminating device to your craft room. With regular use, these tools certainly pay for themselves over time.

APPLICATIONS SOFTWARE

The software programs for Digital Decorating fall into two basic categories. The first is what I call page-layout software. Layout applications let you arrange graphic images, such as clip art or files you've generated yourself, on virtual pages. Software for making greeting cards, stationery, posters, brochures, and other such projects would be considered layout applications.

The other category I call graphics editors. Many graphics editors include rudimentary layout templates, but the overriding feature is the sophisticated, flexible tools they have for modifying an image. With a graphics editor, you can subtly change colors or textures, produce special effects like watercolor or mosaic overlays, do precision resizing and positioning tasks, and create original graphics. Programs designed specifically for scanning images and enhancing photographs are considered graphics editors. Many page-layout programs offer tools that are similar but more rudimentary in their application.

Either type of software contains enough features for you to do most of the projects in this book. If you're uncertain which software you want to buy, try first what you have on hand. When you purchase any hardware—from a PC to a digital camera—it's rare not to receive at least one page-layout or graphics-editing program thrown into the deal. Get acquainted with the features you already have at your disposal. Then read up on the features other programs offer, try what your friends or colleagues use and like, and buy something new where yours falls short. Most of these applications cost under $40, and many come bundled with substantial clip-art libraries.

I regularly use three or more page-layout and graphics-editing programs at a time while working on any given Digital Decorating project. (This does not count all the clip-art libraries I have on hand.) I usually begin and end in a layout program. As I'm working, if I want to change a tiny element of a design to a specific hue, I cut and paste it into a graphics editor, make the desired color change, and cut and paste it back into the layout program. If it's a large file and I think I'll lose too much resolution doing an application swap, I'll save it back to my hard drive instead, open the file directly in the graphics editor, make my change, save it again, and then reopen it in the layout program. When I'm working on a wallpaper border pattern that needs to abut, I use the graphics editor to "surgically" select the image and remove any traces of surrounding white space that might produce visible joins in the final product. Such precision is typically not possible in the page-layout application. As I mentioned earlier, this book won't teach you how to use your particular software, but once you know your own tools, you can easily follow my directions using whatever products you happen to own.

CLIP ART

If you currently use clip art to design greeting cards and decorate invitations, think bigger! In this book you'll see entire room themes derived from stock images. Some of the designs were used as is, except for resizing, while others were produced by combining clip art from the same or different libraries, mixing in original graphics and/or text, and changing the colors to create a desired mood or to match the existing decor.

Personally, I find the hardest thing about Digital Decorating is choosing from the millions of stock images and clip-art files available—not to mention the billions of permutations. You can order clip-art libraries by mail or download them from the Web for free or a small fee (see "Sources and Credits" on page 92). In my experience, the best clip-art files are worth paying for, and you get exceptional value with some of the most popular packages. Several CD-ROMs filled with hundreds of thousands of images for around $30 or less is the norm. Different clip-art libraries will often have some files in common (I've searched through enough of them to know).

As the popularity of Digital Decorating grows, I expect the number of clip-art files and

packages on the market to multiply. Don't be surprised to eventually see CD-ROMs filled with clip art depicting the unique styles of Ralph Lauren, Laura Ashley, and other popular design houses. Part of the reason, I suspect, will stem from their need to regain sales cannibalized from their retail collections as more and more Digital Decorators opt to create their own upscale home furnishings rather than buy them off the shelf. Designers will also want to protect their copyrights, as some Digital Decorators may be tempted to scan images they like from furnishings they already own. Once such fashionable images are available on CD-ROM, designers and Digital Decorators alike will benefit. You might, for instance, produce a wallpaper border with the same motif as your Ralph Lauren–loving neighbor, but yours will reflect an arrangement and color scheme that's uniquely yours.

COPYRIGHT CONCERNS

Unauthorized use and distribution of software programs has been an issue for software developers since the day the copy command was instituted. To a certain extent, casual violations—using an office copy at home or loading one copy on your desktop and another on your laptop—are largely overlooked by both developers and law enforcers. Going after the big fish—multinational counterfeiters—is tough enough. Despite penalties including a maximum fine of $100,000 per violation under civil law, and a minimum fine of $250,000 and a five-year jail sentence for federal crimes, software piracy escalates each year, according to the Business Software Alliance (www.bsa.org) and the Software Publishers Association (www.spa.org).

Now that consumers wield scanners with the same abandon as floppy disks, nothing, it seems, is beyond digital infringement. You like the pattern in that new designer dust ruffle? Wouldn't it look great on your nightstand lampshade? Fabric is a cinch to digitize on a flatbed scanner. Just pop the lid and scan it!

Before you exercise that impulse, however, think. You might own the dust ruffle, but you don't own the design on it. The manufacturer retains that right. Practically speaking, no law-enforcement agency is going to barge into your bedroom, confiscate your lampshade, and slap you with a $100,000 fine. But if your lovely Digitally Decorated room were ever photographed for an article in *House Beautiful* and the manufacturer of the dust ruffle saw your lampshade, you just might be facing a lawsuit.

Even that scenario, in all likelihood, is a stretch. But every Digital Decorator must be aware of copyright infringement and its lawful risks, as digital images are the stuff this craft is made of. The creative tools at your fingertips are limited by two things: your imagination and the rightful use of images. Scan in the wrong one and you violate, however casually, copyright law. Likewise, cut and paste an image without permission from a Web site and you violate the same law. If you take a picture of that dust ruffle design with a digital camera, proving copyright violation may be a little more difficult. At least

when we snap our own photographs on a conventional camera, we own the negatives. The digital variety might fall into this category when first contested. If enough cases of either ilk ever went to court, I suspect it wouldn't be long before a precedent was set in the designer's and/or manufacturer's favor.

A more cut-and-dried matter today involves printed images. There's no problem with your decoupaging a children's dresser with pictures torn from the latest Disney storybook. But if you scan those same pictures into your PC in order to print them on a better paper for the project (or copy them at your local copy center for the same purpose), you'd better not invite Michael Eisner for dinner.

Eventually, copyrights do expire. Generally speaking, modern rights are protected for up to 95 years. They may, however, be effectively renewed—stories and logos into movies and product licensing, for example—as almost certainly every Disney drawing and imprint has been. (For more information on infringement and calculating the life of a copyright, see http://lcweb.loc.gov/copyright/.)

If you run across dusty print materials or artwork and can be relatively sure ownership has lapsed or would never be questioned, it is probably safe to digitize the images. In fact, much of the clip art now on the market was derived in this manner. You'll find everything on file from late-nineteenth-century sepia-toned college yearbooks to rare old English botanical prints. One important difference between them and the expensive originals that collectors covet is the antique paper, which you can easily mimic by tea-staining. In short, stick with clip art, and don't scan in found artwork, designs, or other images unless you're sure you're not violating a copyright.

PRINTING MEDIA

Paper isn't exactly high-tech, but it obviously plays a central role in Digital Decorating. Paper products made especially for printers abound in today's market. The problem with most of these papers is that you'll pay a premium for small packages sporting little labels that say "for inkjet printers." In truth, almost any paper will work in your inkjet printer, and some work even better than the papers packaged expressly for such use.

To determine which papers will work and which won't is a trial-and-error proposition. I experiment a lot. So much so, in fact, that it's hard for me to look at any thin-surface medium—from paper bags to burlap to wood veneer—without thinking about how it might do on a turn through my printer. Because I've worked so extensively with both conventional and nonconventional printing substances, I can generally look at a medium and judge whether it will (*a*) go through my printer without jamming, and (*b*) take the ink without smearing. If I can't determine this by eye alone, usually a touch of the surface will tell me for certain. For instance, plastic, vinyl, or rubbery finishes act as natural repellents to the inkjet's water-based ink. If you try substances with such finishes yourself, your printouts will range from dis-

cernible images that take hours, even days, to dry, to those that never dry or simply puddle on the page.

To create a printable surface from one that's inherently not, I've come up with a trick or two, such as removing certain vinyl coatings with fingernail polish containing acetone. A word of warning, however. If the underlying surface is also dissolvable by the chemical, you'll end up with a mess. Rather than wasting your time experimenting with nontraditional print substances, I suggest you start with known media. The "high quality" inkjet printer papers you can buy in office-supply stores are perfectly adequate for a variety of Digital Decorating projects. Throughout this book, unless I specify a certain medium—such as decal sheets or banner paper—you can assume that basic inkjet paper will suffice.

Once you're familiar with a given technique, you might try substituting other papers for different effects. For instance, an image you intend to decoupage could be printed directly onto self-adhesive craft paper. You'll eliminate

Try printing onto nontraditional surfaces like this paper bag.

the messy step of gluing the image into place. When you're printing a wallpaper border segment-style (see page 23), you might try using parchment paper instead of ordinary inkjet paper to impart a vintage look. Keep an eye out for potential print media sold under various brand names at stores offering craft supplies, art supplies, fabric, hardware, party goods, groceries, gifts, and office supplies. Here's a sampling of media you might try:

Canvas, cotton duck, or
 linen art sheets and
 rolls
Construction paper
Craft magnet sheets (for
 inkjet printers, or not)
Doilies
Drawing paper
Easel paper (tear-off pads
 or continuous rolls)
Inkjet decal sheets
Iron-on suede and fabric
 patches

Kids' craft banner rolls
Kids' doodle pads
Labels of all types
Lace trim
Leather
Nonstretch fabrics
Nonvinyl wallpaper
Paper bags (brown or
 white lunch-type or
 noncoated gift-style)
Paper napkins and table-
 cloths
Paper packaging tape

Parchment
Ribbons (silk or cotton)
Self-adhesive craft paper
Stationery, brochures,
 invitations, greeting
 cards, etc.
Watercolor paper
Wood veneer sheets or
 rolls
Wrapping paper

LOW-TECH TOOLS

You can't Digitally Decorate without a good stock of low-tech tools to go along with the high-tech ones. The list is really endless, but includes a good part of what's available in the average home-improvement outlet, craft-and-sewing store, and garden center. Keep the following on hand:

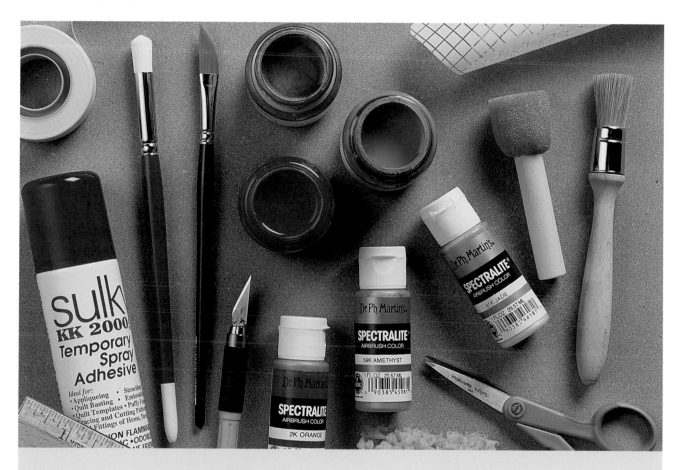

Art-fixative spray
Con-Tact paper
Fabric-basting spray
Foam brushes
Glue
Irons (new and vintage; older irons tend to get hotter)

Iron-on tape
Paintbrushes
Paints
Ruler
Scissors
Sponges
Spray adhesive

Stencil brushes
Tape
Varnish (acrylic or polyurethane)
Wood-burning tool
X-Acto knife

Digital Decorating Techniques

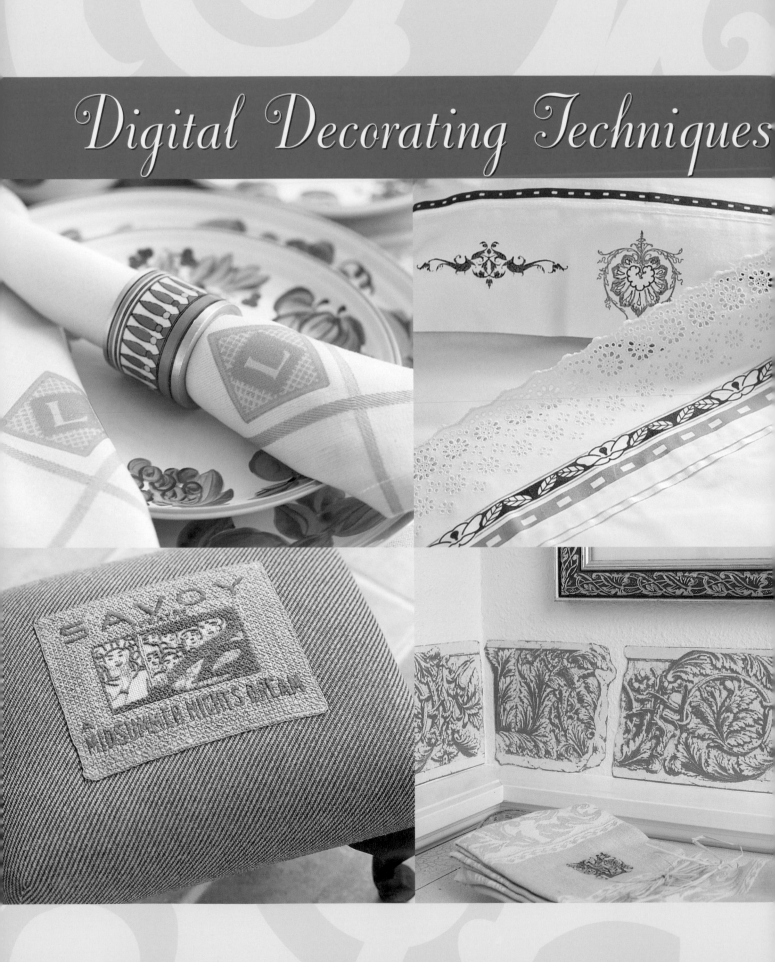

I F YOU WANT TO CREATE BEAUTIFUL, stylish home furnishings, you're not alone. Countless decorating magazines promote the art and how-to of it every month. As I mentioned earlier, Digital Decorating is not about making things look high-tech or futuristic but about helping you achieve the style of home decor that you prefer. You will be working with the same popular styles, design ideas, and decorative touches that you've loved all along, and for this reason you should find Digital Decorating immediately familiar and comfortable.

To introduce digital output into your home's decor, you'll be using new techniques that I have developed as well as older, tried-and-true techniques that I've adapted to the digital format. Decoupage, the first technique we'll discuss, is one of the latter.

DECOUPAGE

The term *decoupage* (from the French for "cut out and affixed") first appeared sometime after the 1920s Art Deco period. It refers to the decorative art of gluing paper cutouts to walls and furnishings, a practice that probably originated in some form in ancient times. Modern-day wallpaper is an obvious offshoot. In the late eighteenth century, Marie Antoinette was said to have covered her palace walls in masterpiece paintings that had been confiscated, cut from their frames, and smuggled to her.

Whenever it really got started, decoupage is alive and well today. Many of the decorative furnishings and accessories sold in trendy mail-order catalogs and on the Internet rely heavily on decoupage for their hand-painted look. The wastebasket project on page 77 looks as if it came right out of one of those catalogs.

As simple as decoupage is, there are numerous ways to go about it. Each approach involves gluing flat media, usually paper, to a smooth surface: walls, wood, metal, plastic, glass, you name it. The top and edges of these paper pieces are then sealed so that they don't lift over time and so that you can apply a protective water-resistant coating over the entire surface. Sometimes I use craft products specifically designed for decoupage, such as crackle medium, but most of my projects can be made with ordinary white glue.

MAKING DECOUPAGE DESIGNS

Materials

White glue

Art-fixative spray

Varnish (acrylic or polyurethane, depending on project)

Scissors (tiny decoupage scissors for very small images)

2 foam brushes (for glue and varnish)

Clean scrap paper

Tissues

Instructions

1. Using your page-layout or graphics-editor software, size your selected image and print.

2. Spray the computer printout lightly with art fixative. Let dry 15 minutes. Repeat. The fixative sets the ink so the image won't run or bleed when you apply the top coating of glue.

3. Cut out the image as close to the edge as possible, eliminating the surrounding white area. Use decoupage scissors to cut small or intricate areas.

4. Lay the image facedown on clean scrap paper. Brush white glue onto the back of the image, going beyond the edges to ensure that the entire surface is coated.

5. Position the image, glue side down, on the project. Press with your fingers or a tissue to adhere it, smoothing out any air pockets. Wipe off excess glue from edges. Check for bubbles periodically, and press them out while the image is still damp. Let dry overnight.

6. Coat the top and side edges of the image with a layer of glue, to form a seal. Let dry overnight.

7. Apply 2 or more coats of varnish. Follow the manufacturer's recommended drying times.

TECH TIP

Use decoupage to coordinate ordinary light-switch and electric-outlet covers to your decor. You can glue on perfectly sized cutouts, printed on plain or canvas paper, of a motif used elsewhere in the room. To tie multiple rooms together, you might use switch covers to carry the same border design throughout your home. Remove the covers from the wall to do the decoupage, and do not reinstall them until the glue and sealer are fully dry.

PRODUCT TIP

A product used extensively in Digital Decorating is art-fixative spray. Artists apply spray fixative to charcoal drawings and similar media to prevent them from smearing. I've found it works equally well on inkjet printouts. The brand I prefer is Krylon Workable Fixatif, sold in art-supply stores. Be careful not to substitute a water-based protective spray, designed to guard fabric from stains. It will dissolve the image.

DECALS

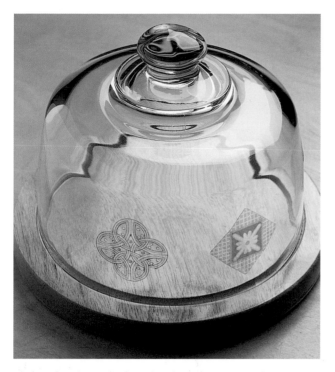

Celtic decals applied to the glass dome of a cheese caddy.

Floral motif printed onto decal sheets and applied to a glass pane. Note how the decals have been trimmed close to the design.

Colorful, see-through decals can be applied to any smooth surface, such as glass, ceramic, metal, or plastic. You can make beautiful "stained glass windows" or create accent tiles for a bath or kitchen. Adorn a plain vase or give lamps a new look. It's so easy.

Decals can be made temporary or permanent, depending on your intended use of the finished project. For nonpermanent use, such as seasonal motifs or decorations for a party, simply print the image you want onto decal sheets, cut out the shape, peel off the backing, and adhere the decal. When you're ready to change your decor, simply lift up one edge of the decal with the tip of an X-Acto knife blade and peel it off the surface. An X-Acto knife can also help you separate the decal from its backing when you first apply it.

Once you've tried temporary decals, it's an easy move to permanent, water-resistant applications—just treat the exposed surface with an acrylic spray sealer after applying several coats of art-fixative spray. This protection lets you use your decals for projects such as my kitchen mural tiles (page 42) or a table lamp base (see page 56).

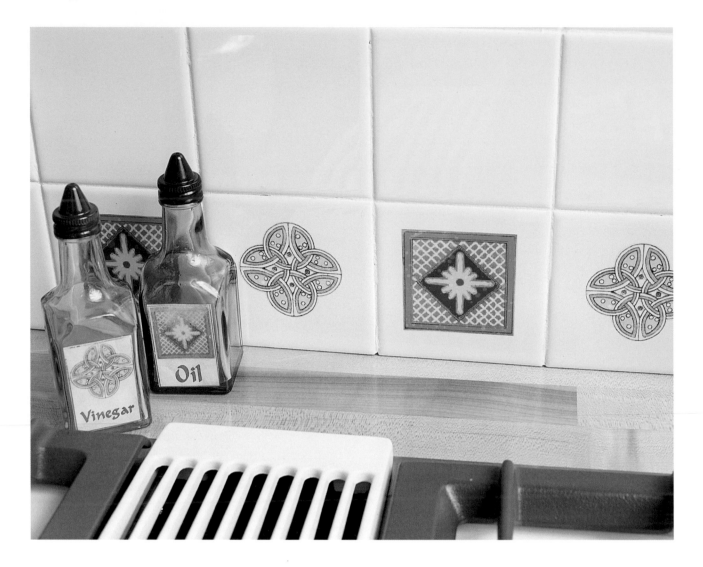

MAKING DECALS

Materials
Xerox "Color Inkjet Window Decals"
Art-fixative spray
Acrylic spray sealer for ceramics (for permanent, water-resistant decals)
X-Acto knife
Scissors
Ruler
Alcohol pads
Scrap paper or cardboard
Paper towels

Instructions
Note: Follow steps 1–5 for temporary decals. Add steps 6 and 7 to make your decals permanent and water-resistant.

1. Using your page-layout or graphics-editor software, size the desired images and print them on decal sheets. To prevent smearing, spray a light coat of art fixative on the printed, uncut decal sheet. Let dry 15 minutes.
2. Meanwhile, clean the surface to be decorated. Wipe it free of dust and remove any dirt or grease with an alcohol pad. Let dry.

3. Cut out the decal carefully. For better adherence, eliminate sharp corners and points. When cutting squares, for instance, I always nip off the corners.

4. Work with clean, dry hands. Slip the blade of an X-Acto knife between the film and the paper backing to separate them, and peel off and discard the backing. Avoid touching the sticky surface to prevent fingerprints (handle much like you would a CD or photograph).

5. Position the decal on the project surface and smooth it in place. The decal film is somewhat forgiving, so if the image isn't aligned or you want to smooth out some air pockets, just lift it by one edge with an X-Acto knife and try again.

6. Once the decal is in place, mask off the surrounding project surface with scrap paper or cardboard. Spray the decal with art fixative, making sure to seal the edges. Let dry 20 minutes. Repeat about 5 times over the next 24 hours, letting each new coat dry longer than the previous one. Let the final coat dry overnight.

7. For a water-resistant seal, apply 3 coats of an acrylic spray for ceramics, following the manufacturer's recommended drying times. Depending on the project, you can mask off the surrounding area as in step 6 or you can spray the entire object.

TECH TIP

- Give your homemade salad dressings, chutneys, and jams a professional edge by adding a Digital Decorating decal to the jar front or lid. Your home-baked goods will take on added panache when you top purchased bakery-style containers with your own personalized patisserie stickers. For more ideas, see "Other Sticky Solutions" on page 25.

- To apply decals to surfaces that are not completely flat, you must size your images carefully. Tiles, for example, have a sloping lip around the edges. If the decal extends beyond the flat surface onto this curved edge, you run the risk of not having a tight, water-resistant seal. Print any potentially tight designs on regular paper first and test-fit them before printing your decal sheets.

PRODUCT TIP

For decal colors that do not smear or run, I recommend using an inkjet printer and "Color Inkjet Window Decals" by Xerox. There are sure to be more and even better decal papers in the future. The manufacture of large 11" x 17" sheets, for instance, is an improvement I eagerly await.

CON-TACT PAPER CREATIONS

Con-Tact paper started life as a dull drawer-and-shelf liner. It has sure grown up! Today you'll find dozens of decorator patterns and colors, as well as different surface finishes and backings. Most popular are the low-tack, repositionable sheets that are so easy to pull off and replace as your tastes and decor change. For Digital Decorating, smooth, white, high-tack Ultra Con-Tact paper is the most useful, but unfortunately, this type is increasingly hard to find. As with many of the products cited in this book, better choices of Con-Tact paper are sure to be available for Digital Decorators in the future. I, for one, would like a paper with a directly printable surface.

In the meantime, I use Con-Tact paper as a backing for computer-printed wallpaper borders. In addition to providing a ready adhesive, this paper helps camouflage uneven wall surfaces and gives flimsy or translucent printer paper more body and impact on the wall. When I want a change in decor, even high-tack borders are easy to remove. Of course, you can always adhere your paper printouts directly to the wall with wallpaper paste, spray adhesives, or ordinary white glue. The final effect will depend on the paper quality you choose and how flat and/or porous the wall surface is. To test your options, do some experimenting in an inconspicuous place, such as the interior of a closet.

TECH TIP

Being ahead of the curve is important when it comes to the products available for Digital Decorating. Take high-quality banner papers and fabrics, for instance. Produced primarily for the professional printing market, they are sold in widths far beyond the capabilities of inkjet printers intended for home use. That will change.

In the meantime, I've taken matters into my own hands, literally, by grabbing a saw. That's right. Whenever I find a roll of paper or fabric that is ideal for a given project but too wide for even my wide-carriage printer to handle, I saw it in half. I get two rolls for the price of one—a not inconsiderable bonus, given the high price tag attached to professional paper rolls.

An electric saw provides a cleaner cut, of course, but a handsaw works just as well if you take your time. Mark your cut line all around the roll. Rest the saw blade on the marked line and pull toward you, sawing only in a backward motion until you create a groove. Then you can begin sawing back and forth. Turn the roll, following your line, and cut through the medium until you reach the cardboard or plastic core. Here the cutting gets a little tougher, but I figure if I can manage it (I'm no weightlifter), most anyone can. I do advise wearing heavy work gloves. It's easy to nick your hands until you get a feel for it.

The instructions below offer two ways to print designs for borders. The method you choose will depend on your printer's capabilities.

MAKING BANNER-PRINTED BORDERS

If your printer supports continuous banner printing, making wallpaper borders becomes incredibly simple. A variety of banner papers can be used for this art. (See pages 41, 53, 59, and 83.)

Materials
Printer with continuous banner mode
Banner paper (made expressly for inkjet printers, or a substitute; see page 13)
Roll of Con-Tact paper
Permanent spray adhesive
Handsaw (as needed)
Scissors
Ruler

Instructions
1. Create a design on a banner page in your layout program. Try to start and end each segment so the ends butt without any extra cutting or fitting. Most layout programs support banner pages up to 10 feet in length. Print the design onto the banner paper.

Spray with art fixative (optional, but recommended in areas with high humidity).
2. On a large, flat work surface, cut a piece of Con-Tact paper to the same length as your printed border design.
3. Spray the right side of the Con-Tact paper with adhesive. Starting at one end, smooth your printed border design, right side up, on the Con-Tact paper. Let dry.
4. Using scissors, cut out the border design through all the layers.
5. Peel off the Con-Tact paper backing and adhere the border to the wall. To reinforce the hold, you may wish to spray adhesive directly onto the wall *before* you apply the border.
6. Repeat steps 1–5 as needed to create a border of the desired length.

MAKING SEGMENT-PRINTED BORDERS

Use the segment method if you have an entry-level inkjet printer that doesn't support continuous banner printing. Don't worry, you'll still be able to make beautiful wallpaper borders. The border in my dining room was printed with this method and you'd never know it, even close up. Noncontinuous "spot" designs are especially easy to produce using this method.

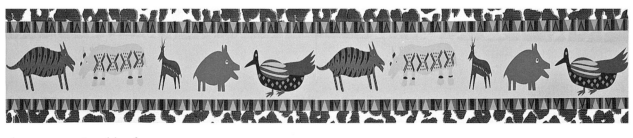

A segment-printed border

Materials

Roll of Con-Tact paper
White glue
Low-tack spray adhesive (optional)
Permanent spray adhesive
Brush for glue
Paper cutter or X-Acto knife, straight
 edge, and cutting mat
Scissors

Instructions

1. Using your page-layout or graphics-editor software, create either a spot design or a design that is easily repeated in segments. Fit as many designs or segments per sheet as possible. Print enough sheets to yield a border of the desired length.

TECH TIP

Unlike commercial wallpaper borders, banner- and segment-printed borders do not roll up neatly once they've been joined to Con-Tact paper. If you are using a Con-Tact paper backing, it's best to add the backing and mount the border on the wall in a single session. On the other hand, printed borders without a Con-Tact paper backing roll beautifully. If you are gluing a border directly to the wall, you can simply unroll it from your hand as you go. You can even use longer lengths if your printer supports them.

2. Cut out each segment. To cut straight edges quickly and accurately, use either a paper cutter or an X-Acto knife, straight edge, and cutting mat.

3. On a large, flat work surface, cut an 8- to 10-foot length of Con-Tact paper (avoid longer lengths as they become unwieldy).

4. Lay the Con-Tact paper right side up on your work surface. Spray lightly with adhesive. Using a low-tack adhesive allows the option of easily lifting up and repositioning the segments.

5. Arrange the segments from step 2 on the Con-Tact paper, butting them end to end. Once they are positioned, lift the edges of each segment one by one, brush with white glue, and press back into place for a permanent hold. Let dry. As you gain practice, you can use permanent spray adhesive in step 4 and apply glue only to those edges that don't completely adhere.

6. Cut around the image as close to the edge as possible and remove the excess Con-Tact paper. Peel off the paper backing and adhere the border to your wall. To reinforce the hold, you may wish to spray permanent adhesive directly onto the wall *before* you apply the border.

OTHER STICKY SOLUTIONS

Con-Tact paper is ideal for a number of other Digital Decorating projects, including what I call "removable wall art"—with the accent on *removable*. The faux stones in the Country Spa fall into this category. In addition to being removable, allowing for instant repositioning elsewhere, the stones have a protective, water-resistant seal. This, of course, makes them perfect for use in a bathroom and creates the look of decoupage without its permanency.

These dual characteristics—a sealed surface and easy removal—create dozens of possibilities for this art in your home. In kids' rooms you can position storybook characters, school artwork, or design themes such as spaceships or lollipops in a random or geometric arrangement. When it's time to rearrange the furniture, just lift the pieces off the wall and reposition them to fit the new layout.

You can also create personalized designs. A midwall display might feature scanned images of a child's soccer teammates framed in black-and-white checks and interspersed with cutouts of soccer balls. Designing the pieces would make a fun parent-child project, and since the cost is relatively low, you won't mind creating something brand-new to accommodate next year's interests.

On a more sophisticated level, removable wall art lets you achieve the vogue look of print rooms. In print rooms, decoupage prints are

Faux stones made with Con-Tact paper

affixed directly to the wall. Antique botanicals, architectural and design-book lithographs, and other collectible printed works are typical choices, and the look is especially effective in hallways, foyers, powder rooms, and dens. Thousands of suitable prints are available in clip-art packages. All you need to do is size them to your needs, print them on parchment paper, give them a decoupage seal, and adhere them to the walls with Con-Tact paper. On smooth drywall, it can be difficult to discern the difference between pieces mounted this way and traditional decoupage. Of course, you can always glue your prints directly to the wall and seal over them for the real thing.

Labels and stickers are a small but fun aspect of Digital Decorating. You can custommake your own labels for jars of homemade jams, chutneys, and other delicacies (page 50); for toiletries such as lotions and bath salts (page 78); or for use in scrapbooks, albums, and recycling projects such as video and CD storage luggage (page 72).

If you want to produce uniform mailing-type address labels, self-adhesive name tags, and the like, presized inkjet labels and sticker sheets are available. But for decorating—even if all I'm doing is labeling a jar of pickles—I find these "cookie-cutter" business labels far too restricting. Fortunately, some label manufacturers have responded to the changing consumer demand for label-making computer papers, and full 8½" x 11" sheets of inkjet labels are now readily available in office-supply stores. Just print and cut to the size you want. Because I began using Con-Tact paper for labels before these cut-your-own-size sheets became available, I've yet to find a reason to switch,

especially when you compare costs between the two media. Another benefit of the Con-Tact paper approach is that you get to choose your own paper, such as parchment for an old-fashioned label.

USING OTHER STICKY SOLUTIONS

Materials
Con-Tact paper
Art-fixative spray
Permanent spray adhesive
Acrylic spray sealer
Scissors
Ruler or tape measure

Instructions
1. Measure the area where you wish to apply a sticker, e.g., the front of a jar. Using your page-layout or graphics-editing software, size the desired image.
2. Print the image. Spray with art fixative and let dry.
3. Lay the Con-Tact paper, right side up, on a flat surface. Apply permanent spray adhesive, following the manufacturer's directions. Adhere the printed image to the Con-Tact paper.
4. Cut out the "sticker" through all the layers.
5. For a water-resistant surface, apply 2 or more light coats of acrylic spray sealer, following the manufacturer's directions. Let dry.
6. Peel off the Con-Tact paper backing and press the sticker in place on the project.

HEAT TRANSFER

Iron-on transfer images for fabrics have been with us for a long time. Vendors of business novelties and sports memorabilia are high-volume users, and prepackaged designs have been available in craft and specialty stores for years. When blank sheets for printing and transferring your own designs first became available, home businesses sprang up overnight and stores always seemed to be running out of white T-shirts. Nowadays, with color printers less expensive than your average VCR, people have started embellishing tote bags, barbecue aprons, visors, and the like (thankfully, T-shirt printing seems relegated to tourist locales). Such crafty projects are actually a great way for you to learn the art of heat transfer. Better you should make your initial mistakes on cotton boxer shorts than an expensive set of raw-silk draperies or linen napkins.

There are actually two types of heat transfer: "hot" and "cold." The names are a bit misleading, as both use a hot iron (cotton/linen setting) to activate the transfer. The difference is that in hot transfers, the paper backing is

Make cold transfers more durable by spraying with polyurethane.

peeled off immediately, while the transfer is still hot, whereas in cool, cool-peel, or cold transfers, you wait until the paper cools before peeling it off. Hot transfers penetrate finely woven linen, raw silk, and cotton fabrics especially well; the transfer really sinks down into the fibers. Cold-transfer images tend to sit on top of the fabric, forming a filmy layer.

I won't say one type is necessarily better than the other. I've found good uses for both. For instance, on woven rugs with an uneven pile, cold transfers can compensate, producing a smooth, continuous image. A hot transfer on an uneven surface, such as a waffled dish towel, breaks up the image, creating a spattered effect (see page 46). Other factors will also affect your choice. Frequent washing will cause cold transfers to fade, become transparent, and eventually peel off in chunks, so they are not really suitable for items like dish towels, which get laundered frequently. But on a rug or floorcloth, which you can protect with a few coats of spray polyurethane, they are fine.

Take the time to get acquainted with both types of transfer, and always pretest the product, even if it's a brand you've used before. Sellers are always acquiring new products through company mergers, tinkering with the formulas, trying out variations they think buyers want. To reduce errors and minimize expenses in the long run, try printing several copies of the same small image on one sheet and then transferring the copies onto a variety of fabrics to judge the various effects. You'll eventually get a feel for what works best for different types of fabric (heating for a longer or shorter time, pressing firmly or not, trimming close or not so close to the image before transferring, etc.). Be sure to experiment with the manufacturer's suggestions, as well.

With all the at-home heat-transfer crafting going on—quilters adore this medium!—supplies remain inexplicably unavailable in craft stores. That will soon change, I'm sure, but in the meantime, you can pick up what you need at your local office-supply or computer store. In this book you'll find dozens of inspiring ideas for using heat transfers in higher style than ever before.

USING HEAT TRANSFERS

Materials
Inkjet heat-transfer sheets (hot or cold, depending on your fabric choice and your desired effect)
Fabric, preferably cotton, linen, or raw silk
Iron
Scissors
Ruler

Instructions
1. In your graphics-layout software, size the desired images and print them onto transfer paper. Be sure to mirror-print words or letters.
2. Trim images as close to their designs as possible. For repeating patterns or borders, leave a ½" margin at one end. Overlap and butt the images, taping on the wrong side. (This eliminates a visible join once the transfer is ironed.)
3. Preheat iron at the hottest setting for at least 15 minutes.
4. Following the manufacturer's instructions, position the image facedown on the project surface and use the iron to complete the transfer.
5. Wash fabrics with transfer images according to the transfer manufacturer's instructions.

Some products instruct you to cut out the image with a substantial margin—even giving it a frame. Others say you should trim as close to the design as possible. I prefer close trimming. It produces a more professionally printed image, as if done at a textile mill. Many makers advise you to leave a lip or small edge on the trimmed image, which you fold back before ironing. The idea is to make the peeling easier. Personally, I don't find this necessary. If the image has transferred well, it lifts naturally from the fabric when you bend it slightly at the edge. Edges with a lip can appear grainy and less well defined, and they don't wear as well.

Most heat-transfer manufacturers recommend you work on a flat, hard surface. Rather than using my kitchen countertop (the implied surface), I set a 1" x 10" x 36" laminated shelving board, wrapped tightly in a pillowcase, atop my ironing board. When I'm not applying a heat transfer, I just set the board aside. This way, I don't need to leave my studio or carry fabrics into the kitchen to do heat transfers. I can also handle large pieces like draperies and duvet covers, which would be practically impossible to manipulate on a kitchen counter.

COLOR BURNISHING

In the heat-transfer methods discussed above, you print your image onto a special transfer paper and then iron it onto the fabric. Color burnishing, in contrast, lets you transfer color inks that are printed on ordinary paper. You can burnish fabric, wood, and even walls. You can also burnish plastic, glass, ceramic, and mirrors (more about that in "Professional Color Transfer" on page 37). The technique is easy but can be expensive. Start with the "simple burnishing" method, which uses color copier printouts, then graduate to "dense burnishing" using your own equipment.

SIMPLE BURNISHING

Most color copiers use a waxy ink that, once outputted to regular copier paper, can be "melted" onto an accepting surface with a very hot instrument. Regular household irons do wonders with images printed on special transfer paper, but they don't get hot enough to burnish color-copier ink from regular paper. For that you'll need (ideally) a professional 400°F non-steam iron or press, but you can substitute a handheld wood-burning tool with a flat tip. Practice before tackling a real project. The

Burnished chair rail

paper will brown considerably as you go, and it's easy to blacken and burn the underlying surface. Don't worry about a slight browning. It can make for a charming patina, a la Provençal café.

As you try the various color copiers in your area, you're sure to find nuances in the burnishing abilities of different brands and models. You may also be surprised to discover greater or lesser color penetration from the same model copier—from week to week—depending on the type of paper the copy center uses. Always do a few tests before starting a new project.

DENSE BURNISHING

Going digital all the way with your own PC setup and eliminating the need for an outside color copier is the more efficient way to produce images for burnishing. If you use the right ink, the image will saturate the surface even more densely than simple burnishing. Many color thermal and some color laser printers utilize a printing medium similar to that of color copiers, so if you're already using such a printer for Digital Decorating (instead of a

color inkjet printer), go ahead and try it out for burnishing to see how the inks behave.

To use a color inkjet printer for burnishing, you'll need to retrofit it with sublimated-dye cartridges. They're not cheap: A typical color inkjet cartridge runs between $35 and $50, while sublimated-dye cartridges start at around $200. You can buy cartridges tailored to popular, thrifty models of inkjet printers through third-party sellers. (I discuss this further in "Professional Color Transfer" on page 37.) Keep in mind that any additions you make may be at your own risk. Just because your Epson printer can be fitted with a third-party cartridge doesn't mean that Epson endorses this capability. Should something go wrong with your printer once it's been used with a cartridge not made by the printer manufacturer, regardless of whether the failing was caused by the cartridge, your product warranty could be void. So know what you're getting into before you venture into this area.

TOOL TIP

Once you start color burnishing, you'll find you want a hotter iron. A wood-burning tool with a flat tip is an excellent and affordable instrument to start, but working with the small tip is time-consuming. For an alternative, check out used appliance stores, flea markets, and garage sales for vintage irons, which heat hotter than today's models. You might even find an old cleaner's press that works. Just be sure no steam is emitted, because steam interferes with the transfer process. Ultimately, you may want to invest in a professional press. But they're pricey: It's tough to find one that heats to 400°F for less than $500. I expect prices to drop and newer models to become available as more people discover Digital Decorating.

USING COLOR BURNISHING

Materials

Access to a color photocopier (for simple burnishing) *or* inkjet printer equipped with sublimated-dye cartridges (for dense burnishing)

Fabric, wood, plaster, drywall, or other porous surface (may be painted but not varnished)

Flat-tipped wood-burning tool, vintage iron, or professional (400°F) iron

Scissors

Tape

Instructions

1. Using your page-layout or graphics-editor software, size your image and print. If your printer is not equipped with sublimated-dye cartridges, take your printout to a copy center and make a color photocopy of it.

2. Cut out the printed or photocopied image, leaving a slight margin all around for taping.

3. Position the image, facedown, on the project surface. Tape in place.

4. Preheat the wood-burning tool or iron for more than 15 minutes.

5. Press the wood-burning tool over the wrong side of the image in firm, quick, even strokes. Or, press the iron gently and quickly in an up-and-down motion. Know the heating potential of your equipment, and turn it off periodically as you go, if needed, to avoid scorching or burning the project surface under the paper image. Lift and check your work occasionally and reheat any areas that are too light before removing tape.

TECH TIP

Color burnishing offers boundless decorating possibilities for outdoor living areas, from decks and lawn furniture to mailboxes and home welcome signs. Adirondack chairs become real works of art with color-burnished beach scenes on their backs. You might burnish a decorative border around your deck's railing, or give the deck itself a whimsical flower path. Dress up your mailbox, make your own house numbers, or create a welcome plaque at the foot of your driveway announcing your "estate" to guests. With its naturally aged quality—reminiscent of a Western saloon or a 1920s smoking room—color burnishing eliminates the need for modern distressing techniques. A few burn marks here and there can really add to the character. Give your outdoor woodwork a thorough varnish and polyurethane coat for lasting designs. For hand-painted looks indoors, burnish designs—even murals—on your walls! Slight imperfections become all the more artistic, as in the dreamy fairy and butterfly "fresco" shown here.

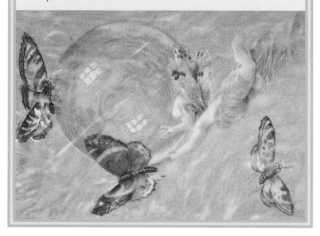

STENCILS

Craft stores are loaded with stencils and related products for transferring prepackaged images directly onto walls. Much of what's available is stylish but not unique; the same images are available just about everywhere. Commercially marketed stencils can be pricey, especially those that produce large, trompe l'oeil–type murals. You can, of course, purchase blank stencil sheets and cut your own stencils for less cost, but if you take your patterns from popular books and magazines, you're still running with the crowd.

MAKING STENCILS

With Digital Decorating, you can create your own highly affordable, personalized custom stencils. If you follow the instructions below, you can also eliminate some of the traditional

steps involved in stencil making, such as tracing or copying a pattern onto blank stencil sheets.

Materials

Self-adhesive light card stock or blank stencil sheets
Acrylic craft paints
Fabric-basting or stencil spray (as needed)
Stencil brush
X-Acto knife and cutting mat
Scissors
Paper plate
Paper towels

Instructions

Note: The following instructions are for self-adhesive card stock. To use blank stencil sheets, follow steps 1–4, print your design on regular inkjet paper, and then follow the manufacturer's instructions to transfer and cut your stencils.

1. Select or create your stencil design on-screen. Simple line drawings with defined cutout areas work best. Intricate, realistic images are usually not suitable.
2. Color the on-screen image so it's easier to see. A two-color stencil, for example, might feature chartreuse leaves and violet flowers.
3. Size the image to fit the surface area you want to stencil. By using your computer software, you can easily resize the same image for different applications. For example, you might make one size of your motif for the wall and a smaller size for decorating a chest of drawers in the same room.
4. "Frame" the image with a thin-lined rectangle, allowing at least ¾" white space between the image and frame all around.
5. Decide whether your design requires multiple color overlays. If the design is simple and the color areas are bold and distinct, you can use a single stencil and just change colors on your brush as you go. If the design is more complex, with colors running close together or overlapping, you will need to create a separate file for each color. Be sure to maintain the rectangular frame position for each separation as you cut and paste. Use the software's color-separations feature, if available, to simplify this task.
6. Print the image onto self-adhesive card stock. If your stencil uses color overlays, print one image for each color.
7. Use an X-Acto knife and cutting mat to cut out and remove the appropriate colored-in areas from each stencil.
8. Cut each stencil on the frame line added in step 4. This rectangular outline will help you align the stencil (especially helpful with wall borders) and will also serve as an overlay guide to stencil multiple colors.
9. To use the stencil, peel off the paper backing and adhere the stencil to the project surface. Pour a small puddle of paint on a paper plate. Dip the end of the stencil brush in the paint and dab off the excess onto a paper towel until the brush is almost dry. Now, pounce the brush in quick vertical movements over the stencil cutouts to transfer the color to the project. When all the area to be colored has been covered, remove the stencil and reposition it on the next area to be stenciled. The self-adhesive sheet will readhere dozens of times. Should the stencil lose its tack, lightly coat the back with fabric-basting or stencil spray, or make a new stencil. Let dry.
10. Repeat step 9 for each color overlay, as applicable.

DIRECT MEDIA PRINTING

If there were such a thing as Extreme Digital Decorating, this would be it. Running nontraditional materials through your printer, such as denim and wood veneer, is not exactly a beginner's sport. At the same time, it's not all that difficult. It just requires that you know your equipment well, prep your materials properly, and don't push beyond the limits.

To get your feet wet, try some of the ready-to-print nontraditional formats now available.

For example, Xerox sells 8½" x 11" sheets of what it calls canvas. It's not really the cotton-duck variety you'd find in a fabric store or even the prepped painter's canvas sold in art-supply stores. It's more of a mock canvas, a textured paper with a semigloss finish that is naturally smudge-resistant. I used it for the backgammon game-board surface (see page 64).

Epson makes a banner canvas that has an entirely different texture from the Xerox

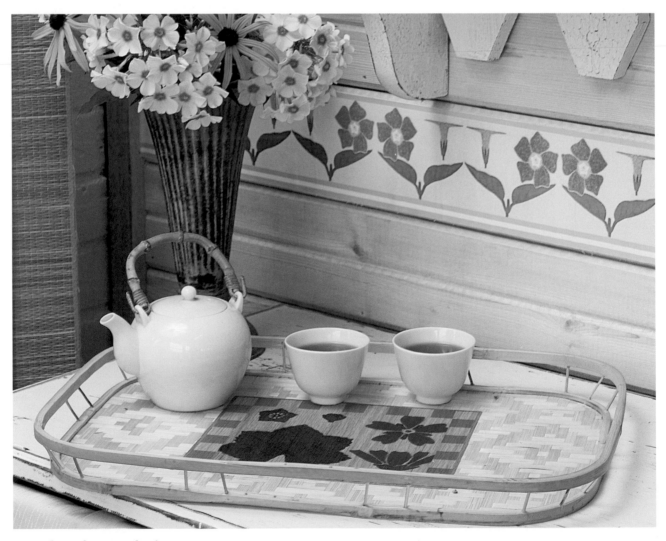

Printed wood veneer glued to a serving tray

canvas—more of a thin-plastic feel. Sold in 15-foot rolls, it was designed for professional banner printing and has a matching high-end cost—approximately $140 a roll. Prices are sure to come down and the sizes made more suitable for home use as more Digital Decorators discover it. For now, I saw the roll in half, and get twice as much for the money (see the Tech Tip on page 22). While Epson does not claim the product is waterproof or even water-resistant, I found it can withstand a sprinkling without the colors running, which is why I chose it as the banner paper for the "Kitchen Collection" wallpaper border.

Printer-ready fabrics are also becoming increasingly available. Basic 8½" x 11" muslin sheets have been around for some time. They run well through any inkjet printer and, with special care, can be dry-cleaned. Sold in craft stores, they are not cheap. Expect to pay around $4 per sheet.

More economical, not to mention creative, is making your own sheets from straight-grained fabric. Light-colored cottons and silks work best, but I've also used darker colors with success,

depending on the image being printed. (Trust me, don't bother with black.) Stonewashed or faded denim takes printing especially well. Prints are useful for certain effects. Absolutely avoid stretchy fabrics—you risk paper jams and, worse, destroying the printer heads. Likewise, don't run fabric cut on the bias through your printer.

MAKING FABRIC PRINTER SHEETS

Materials
Nonstretch fabric, cut to 8½" x 11"
8½" x 11" light card stock
Fabric-basting spray
Tape (avoid extremely tacky tapes)

Instructions
Note: Refer to the Tech Tip below.

1. Apply fabric-basting spray to one side of the card stock.
2. Carefully smooth fabric onto the card stock so it lies absolutely flat. The basting spray allows easy repositioning.

TECH TIP

Get in the habit of baby-sitting nonconventional media as they pass through your printer. Wood veneer and even card stock manufactured for inkjets can benefit by a gentle push of the sheet as the printing starts. If you don't do this with thicker sheets, sometimes the printer can't perform its initial "grab" and may confuse this with an out-of-paper error. Or worse, it may grab the sheet but misalign it, skewing your final printout or creating a paper jam.

If your printer allows for manual or straight-path printing, use it. Don't forget to set your software to manual feed and turn off any options you may have for automatic paper-size sensing. Otherwise, the printer will try to grab paper from its tray rather than the sheet you're trying to feed manually. Or, if the paper tray is empty, the printer will just sit idle with its "paper-out" light on.

When I baby-sit my printer and its print medium to start, I usually stick around for graduation. If need be, I gently pull the medium as it emerges from the printer. My attention has paid off. I can count on one hand the number of paper jams I've had while Digital Decorating.

3. Cut an 8½" length of tape. Lay the tape lengthwise along one short edge of the fabric sheet, half on and half off. Turn the sheet over and press the remaining tape onto the card-stock back. The objective is to give the sheet a smooth, even entry edge for the printer to grab onto.

4. Select the printer's straight-through paper-path option if available. Print the image onto the fabric side of the sheet.

5. Carefully remove the card stock and tape.

TOOL TIP

One manufacturer, Jacquard Products, is leading the way in producing inkjet-ready fabrics that can be washed after being treated with special post-printing products. Jacquard sells cartridges containing special fabric-penetrating dyes as complete packages for certain popular printers. Entry-level, permanent printing systems, including a wide-carriage printer and inks, run about $2,000. If that starting price makes you gulp, get ahold of Jacquard's catalog (see "Sources and Credits" on page 92) and send for samples of its magnificent selection of printer-ready fabrics, sold on rolls in widths ranging from 8½" to 42". At last count, Jacquard offered more than sixty different fabric types and embossed patterns, including wool flannels, linens, gauze, crepe de chine, and silks. See the folding-screen project in the Garden Room Collection for an example of Jacquard's Silk Habotai (page 87). For a really special gift (or just to treat yourself), print your own custom designs on oversized silk squares, roll the edges, and you've got a scarf worthy of a Fendi or Gucci label. Jacquard's inkjet fabrics are that fine.

PROFESSIONAL COLOR TRANSFER

While Jacquard Products has been opening up professional inkjet fabric printing, several other vendors have been doing the same for heat transfer. Companies that specialize in high-end heat-transfers use their own special cartridges. (One such company is Conde Systems; see "Sources and Credits" on page 92.) They sell and equip popular inkjet printers for heat-transferring images onto everything from sportswear to coffee mugs. You'll want to use the paper recommended by Conde, as I did for the chair rail in the Family Room Collection on page 60 and the wooden hot plate shown below. Other companies, such as

Geo Knight, sell specialty superheat presses. Such presses allow the sublimated-dye images to penetrate surfaces like porcelain and ceramic, as if they'd been painted and kiln-fired. As you might expect, these professional systems are not inexpensive. Prices for Conde's entry-level sublimated-dye systems are comparable to Jacquard's beginning printing systems. But Conde also sells cartridges separately, starting at $200, and you can use these in certain Epson printers, one of which you might already own. Just don't use the printer for ordinary inkjet printing once it's taken the dyes.

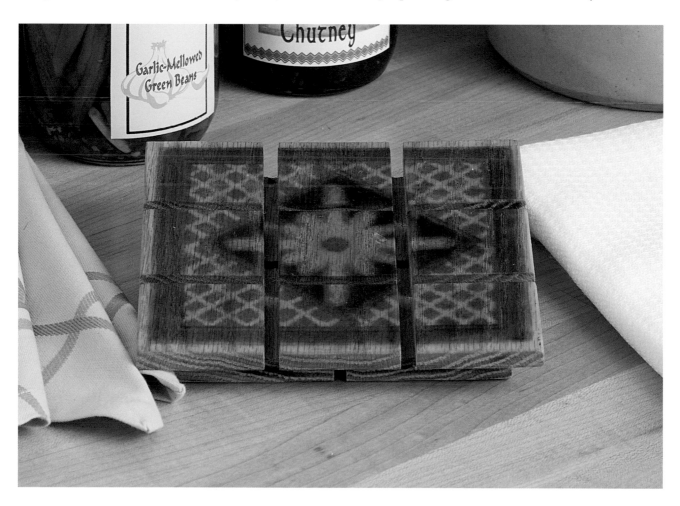

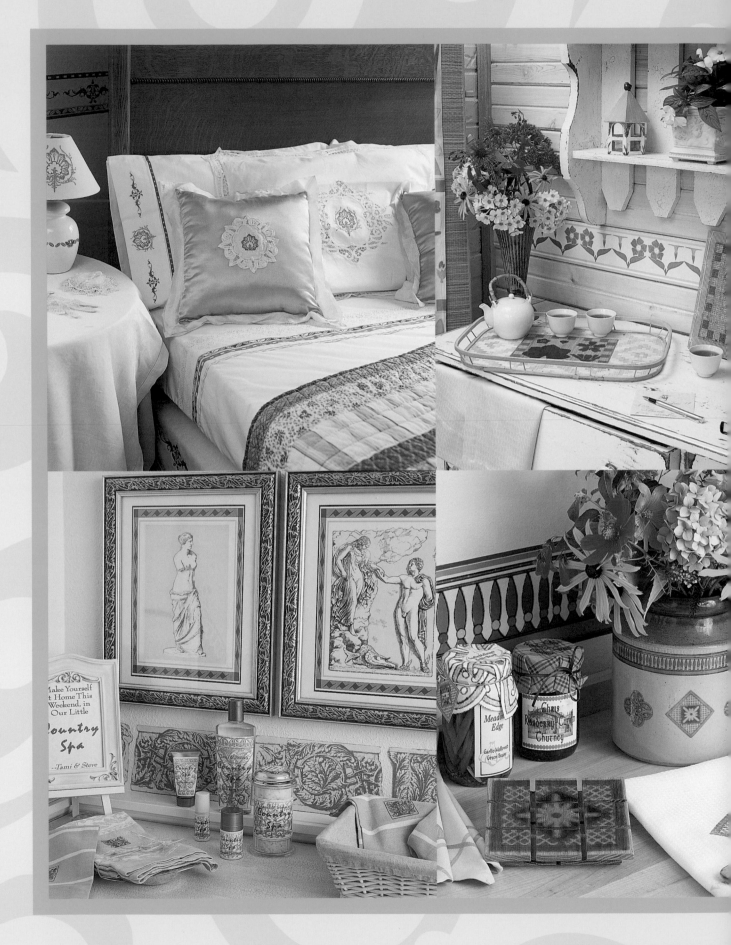

Part 2
Designs for Living

Kitchen Collection

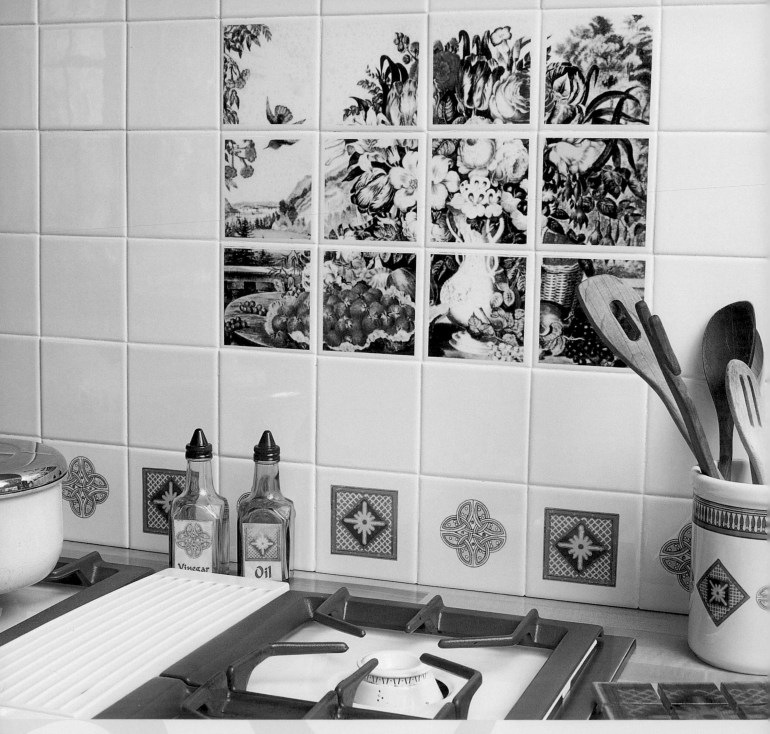

THIS ECLECTIC EUROPEAN COUNTRY-STYLE kitchen is pulled together in three distinct ways. Deep gray-blues, sage greens, and the three primary colors do the color work. A floral motif used in the tile backsplash appears again on the stools, geometric accent tiles, dish towels, place mats, and monogrammed napkins. Finally, the Tuscany-inspired wallpaper border surrounds the room in Old World charm. The same design encircles various crockery, serving glasses, and napkin rings.

TUSCANY
WALLPAPER BORDER

I chose to print this border onto an Epson canvas banner roll, since the medium has a pleasing texture and resists ordinary kitchen humidity. Because the roll is too wide to fit even my wide-carriage printer, I used a handsaw to cut it in half. As with most of my designs, this wallpaper pattern was derived from clip art. I took the file, which appeared to be a scan of actual Old World wallpaper or perhaps a hand-painted border, and began tweaking its colors to match the decor I wanted in this kitchen. I could easily have cleaned up the file while I was at it, but I decided to retain its mottles and chips, as I loved the patina. I did, however, add coordinating colored lines at the top and bottom to give the border contemporary flair.

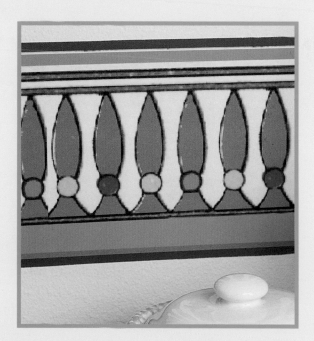

Materials

Printer with continuous banner mode

Epson canvas banner roll (or other banner
paper)

Roll of Con-Tact paper

Permanent spray adhesive

Handsaw (optional)

Scissors

Ruler

Instructions

Follow steps 1–6 under "Making Banner-Printed Borders" on page 23. Refer to the Tech Tip on page 22 if you need to saw the banner paper roll in half to fit your printer.

MURAL AND ACCENT TILES

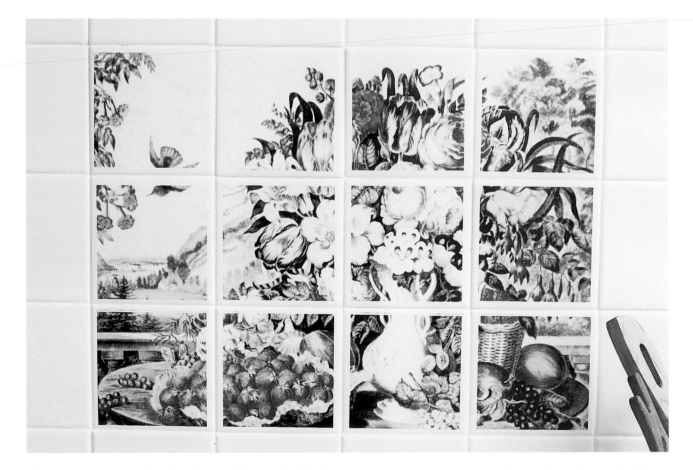

These custom-made kitchen tiles only look expensive; they are actually created using computer-printed decals. With Digital Decorating, you can print identical "tiles" for a border design or create a colorful mural above your sink or cooking area. This mural coordinates with the kitchen's colors and adds life to what is otherwise a utilitarian backsplash. Both

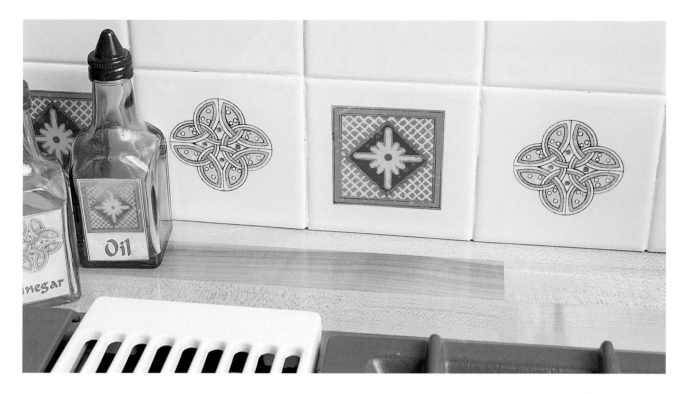

the accent tiles and the mural were selected from a clip-art library, but you don't have to stop there. You might try creating tiles with your own artwork, or you could scan a photo of your garden and then digitally enhance it for a watercolor effect.

Materials

Xerox "Color Inkjet Window Decals"

Art-fixative spray

Acrylic spray sealer for ceramics (for permanent, water-resistant decals)

X-Acto knife

Scissors

Ruler

Alcohol pads

Scrap paper or cardboard

Paper towels

Instructions

Follow steps 1–7 under "Making Decals" on pages 20–21.

- To print accent tiles, simply decide on your design and print as many as will fit on each 8½" x 11" decal sheet until you have the number required.

- To print tiles for a mural, enlarge the screen image to match the final image area. If your software supports poster printouts, you'll be able to work on-screen in the full size of the mural. If not, just work with an oversized picture that extends beyond your page margins. Shift the picture around, bringing workable, printable areas into view until you've correctly sized and printed each square. The mural shown was enlarged to fit an area four tiles across by three tiles down, with each tile pictorial measuring 3½" x 3½".

- For added interest, design a border in a coordinating color and copy it onto each square of the mural.

COUNTER STOOLS

A popular country-kitchen catalog sells stools with the same hand-painted look I've done here for $279—per stool! I started with unfinished wood stools, purchased from a popular import store for less than $20 each. You'll need a painterly picture, like the one I borrowed from the kitchen's tile mural, for the decoupage seat. The remaining surfaces are hand-painted to coordinate with the rest of the kitchen. The tiny antique gold stars encircling the picture are a stenciled version of one of my accent tile designs. To suggest an antique patina, I used the tip of my brush and two paint colors to marbleize the legs.

Materials
Unfinished-wood counter or bar stools
Acrylic craft paint and/or latex paint
Acrylic or polyurethane varnish
White glue
Art-fixative spray
Fabric-basting or stencil spray (as needed)
Stencil brush
Paintbrushes
Foam brushes
X-Acto knife
Scissors
Ruler
Self-adhesive light card stock

Instructions
Note: Refer to "Making Decoupage Designs" on page 18 and "Making Stencils" on page 32.

1. Paint each stool as desired. You may wish to leave all or portions of the wood unfinished. For example, you might paint the seat only (the part that will be covered by the decoupage) and leave the legs natural.

2. Using your graphics-editor software, size the image for the stool seat and print the required copies. For variety, you might prepare several different but coordinating images, so each stool is unique. Spray with art fixative and let dry.

3. Cut out each image and glue to a stool seat. Let dry overnight. Seal the top layer and edges with a thin coat of glue. (See "Making Decoupage Designs," steps 3–6, on page 18.)

4. Paint additional designs as desired. I painted a circle freehand around the decoupage image using a ¼" flat brush and latex paint.

5. Add stenciled motifs as desired. I resized a star from my accent tiles to 1" to make a stencil. Using antique gold acrylic paint, I stenciled 16 stars around the decoupage image. (See "Making Stencils," steps 1–9, on page 33.)

6. Let the stool dry overnight, or longer if you live in a humid climate. Apply 2 or more sealer coats, following the manufacturer's recommendations. I applied 5 heavy coats of varnish to these stools.

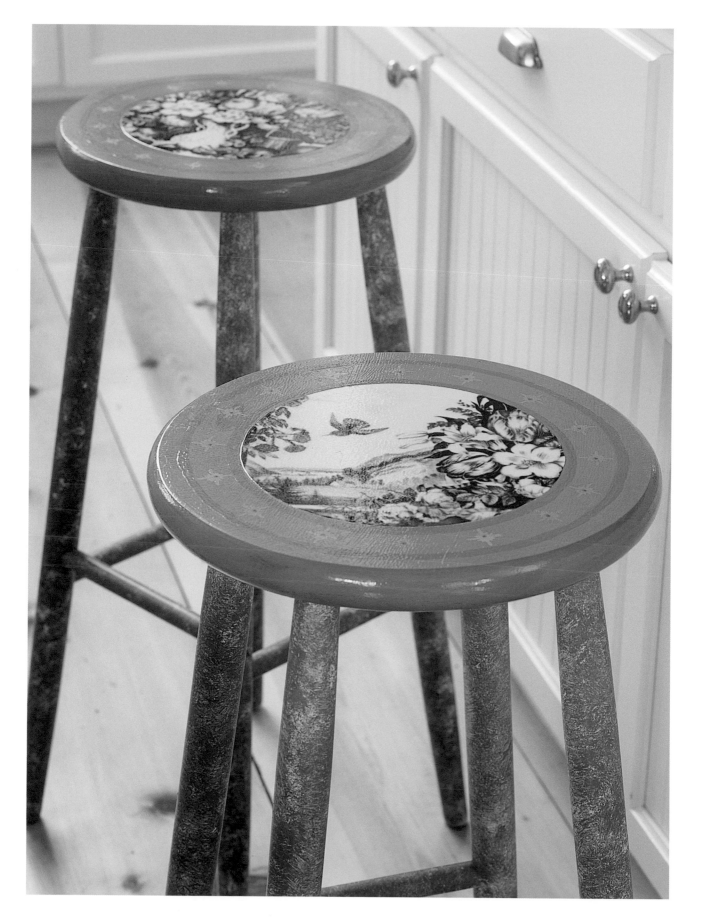

KITCHEN LINENS

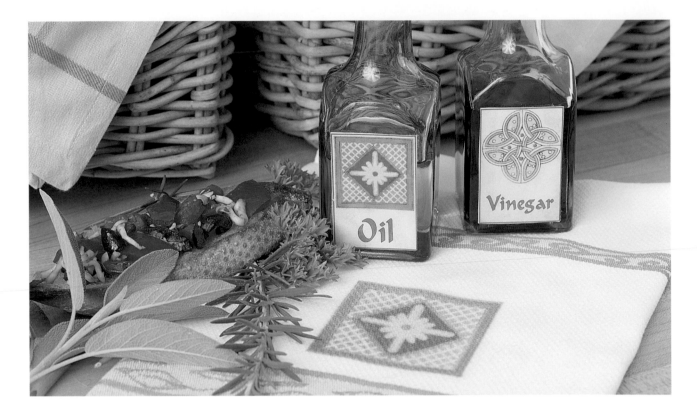

"Hot" heat-transfer sheets were used to adorn the dish towels, place mats, and napkins for this kitchen. For further customization, you might also monogram your linens, as I did with the napkins.

Materials
Inkjet "hot" heat-transfer sheets
Assorted kitchen linens (place mats, napkins, dish towels)
Iron
Scissors
Ruler

Instructions
Follow steps 1–5 under "Using Heat Transfers" on page 28.

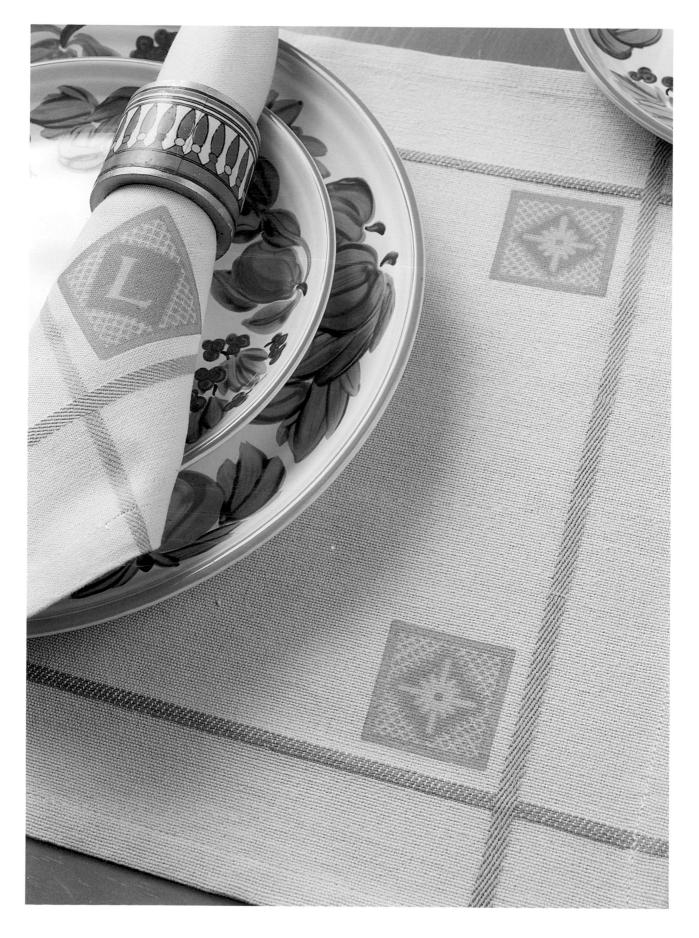

ACCESSORIES

WALL CLOCK

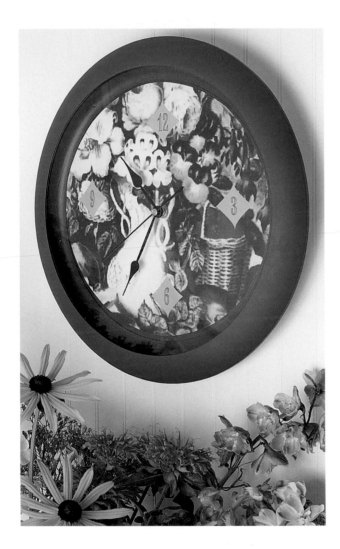

Behind their protective clear plastic covers, even the classiest designer clocks use simple printed papers to decorate their clock faces. Print your own design, slip it into a $10 clock, and you've got an accessory that could easily cost eight times as much in a trendy shop or gift catalog. This version uses a Con-Tact paper backing so you can easily remove the design if you want to change it at a later date.

Materials
New or used large round clock
Con-Tact paper
Art-fixative spray
Permanent spray adhesive
Scissors
Ruler

Instructions
Note: Refer to "Using Other Sticky Solutions" on page 26.

1. Carefully disassemble the clock so the face is exposed. Remove the clock hands. Measure the clock-face diameter.
2. Using your page-layout or graphics-editor software, size your image to the same diameter. Add clock-face numerals as desired.
3. Print the image. Spray with art fixative and let dry.
4. Lay the Con-Tact paper, right side up, on a flat surface. Apply permanent spray adhesive, following the manufacturer's directions. Adhere the printed image to the Con-Tact paper.
5. Nip a hole in the center of the printed clock face to accommodate the clock workings.
6. Cut out the clock-face "sticker" through all the layers.
7. Peel off the Con-Tact paper backing and press the sticker in place on the clock. Reassemble the clock.

ROCKERY AND GLASS

Ordinary glass and ceramic canisters and serving pieces are easy to decorate with inkjet decals. By applying a similar design to each, you can pull together your own coordinated set from otherwise disparate pieces. The motifs used here were copied from the kitchen's wallpaper border and accent tiles.

Materials

Xerox "Color Inkjet Window Decals"
Glass or ceramic kitchenware
Art-fixative spray
Acrylic spray sealer for ceramics (for permanent, water-resistant finish)
X-Acto knife
Scissors
Ruler
Alcohol pads
Scrap paper or cardboard
Paper towels

Instructions

Follow steps 1–7 under "Making Decals" on pages 20–21.

- Using your page-layout or graphics-editor software, resize the wallpaper border to a 1" height. Print strips long enough to fit around each canister.
- Resize the tile and linen motifs so that you can fit eight images (four of each design) around your *smallest* canister. Adhere the same-size images to your larger canisters, but increase the spacing between them, to give the appearance of a matched set.
- On clear glass pieces, such as the cheeseboard dome (page 19), use fewer images for a cleaner look.

NAPKIN RINGS

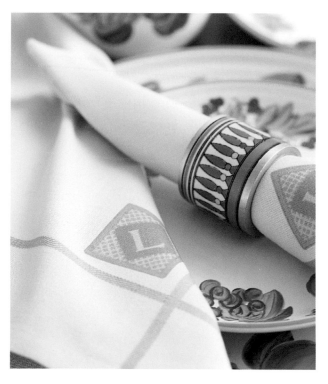

The kitchen wallpaper border turns up again on a set of napkin rings. The decoupage coating does double duty in making the napkin rings waterproof for table use.

Materials

Plain, round napkin rings
White glue
Art-fixative spray
Narrow foam brush
Scissors
Tape measure

Instructions

Note: Refer to "Making Decoupage Designs" on page 18.

1. Measure the width and circumference of a napkin ring.
2. Using your page-layout or graphics-editor software, size the desired image to fit around the napkin ring. I sized my image slightly narrower than the ring and added ¼" to the circumference for overlapping the ends.
3. Print an image for each ring. Spray with art fixative and let dry.
4. Cut out each image and glue it around a napkin ring, overlapping the ends. Let dry overnight. Seal the top layer and edges with a thin coat of glue. Repeat this sealer step if necessary. (See "Making Decoupage Designs," steps 2–6, on page 18.)

WOODEN HOT PLATE

What appears to be an artfully stained design atop this wooden hot plate took just minutes to make. All I did was print out one of my accent tile motifs, using an inkjet printer equipped with sublimated dyes. Then I burnished it onto the wood using a very hot vintage iron. If you don't have a sublimated-dye printer, try the same technique using color photocopies of your designs.

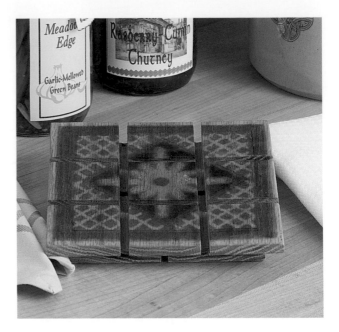

Materials

Access to color photocopier *or*
 sublimated-dye inkjet printer
Plain wooden hot plate
Varnish (brush-on or spray)
Flat-tipped wood-burning tool or
 vintage iron
Scissors
Tape

Instructions

Follow steps 1–5 under "Using Color Burnishing" on page 31. Seal the finished hot plate with a light coat of varnish.

GOURMET HOSTESS GIFTS

If you've gone to the trouble of making your special raspberry jam or pear chutney, why settle for a plain white label on the jar? The custom labels you create with Digital Decorating will give your gourmet specialties extra panache that's worthy of gift giving. Be sure to add the acrylic coating for a water-resistant surface.

Materials

Homemade preserves, relishes, condiments, etc., in glass jars or bottles

Con-Tact paper

Art-fixative spray

Permanent spray adhesive

Acrylic spray sealer

Scissors

Tape measure

Instructions

Follow steps 1–6 under "Using Other Sticky Solutions" on page 26.

- Measure the jar or bottle with a tape measure to determine the label size and shape.
- Get beyond the rectangular label. Most page layout applications include a wide assortment of picture frame and border files that can be configured in just about any shape you desire: round, octagonal, oval, etc.
- To obtain design ideas, study the labels on your favorite foods, drinks, and delicacies. Today's wine labels are especially creative.

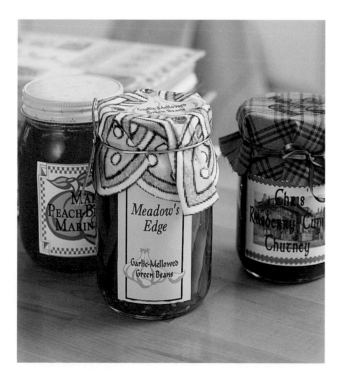

JAR TOPPERS

Dress up your pantry presentations even more with jar toppers, made from either paper or fabric. Encircle the topper with a beautiful ribbon, raffia, or elastic metallic cord.

Materials

Inkjet heat-transfer sheets

Thin paper (for paper topper)

Lightweight cotton, muslin, or burlap (for fabric topper)

Ribbon, raffia, or cord

Iron

Saucer or plate (see step 3)

Scissors and/or pinking shears

Ruler or tape measure

Pencil

Instructions

1. Measure the jar lid. In your graphics layout software, size the desired image to fit within this circle, allowing a ½" margin all around.
2. Print the image onto lightweight paper (for a paper jar topper) or onto an inkjet heat-transfer sheet (for a fabric jar topper).
3. Find a saucer or plate, preferably clear glass, that's about 2" larger than the jar lid all around.
4. For a paper topper, use the plate to draft a circle around the printed image. Cut out with scissors. Skip to step 6.
5. For a fabric topper, use the plate to draft a circle on the desired fabric. Cut out with scissors or pinking shears. Transfer the image to the center of the fabric circle, following "Using Heat Transfers," steps 2–4, on page 28.
6. Place the topper over the jar lid and secure around the neck with ribbon, raffia, or cord. To add a gift card, punch a hole in the card and thread the cord through it before you tie.

Bedroom Collection

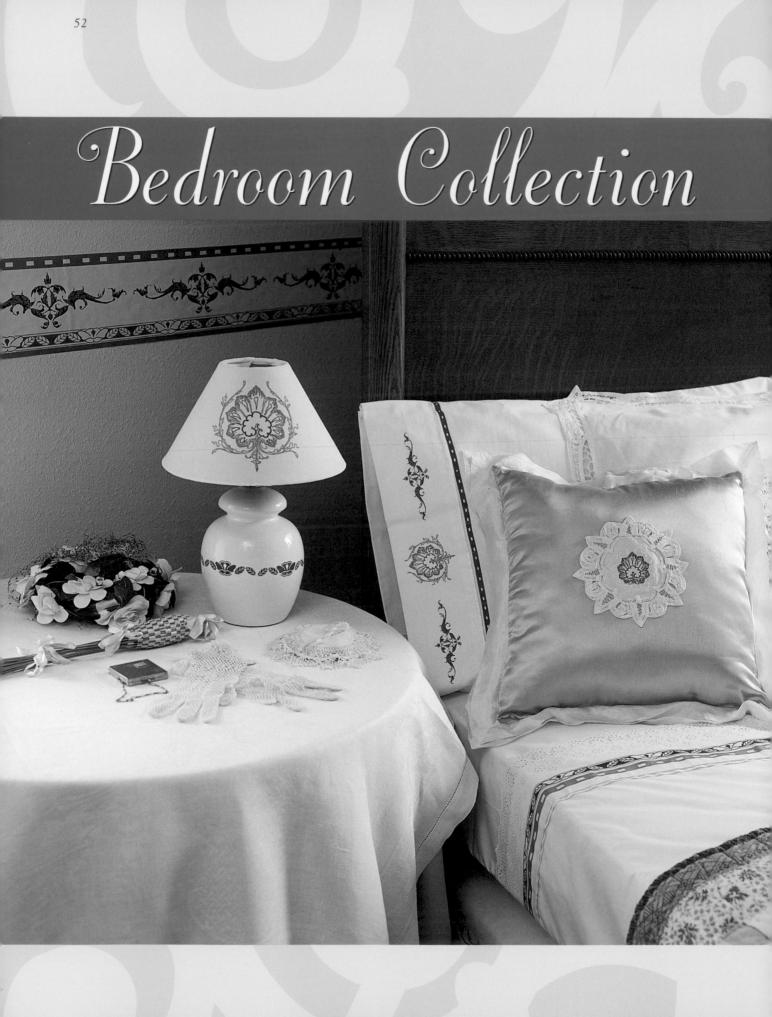

THIS BEDROOM COLLECTION SEEMED TO create itself once I'd decided on the wallpaper border. Each of its elements plays out naturally, reappearing in projects used throughout the room. The ease with which this room came together shows. There's comfort to the ensemble's coordination, and whimsy to offset its elegance. With Digital Decorating, you can get your own designer looks without designer costs.

WALLPAPER BORDER

I combined various clip-art images on-screen to design this wallpaper border. The scrolled images were suggested by items I already owned: a country bed-cover and matching shams, an antique musical jewelry box (from a friend's curio shop on Manhattan's Lower East Side), and colored-glass botanical lithographs. My banner paper for this project was a $2 roll of kids' craft paper, which I chose not only for its low cost but also to demonstrate an alternative print medium.

Materials
Printer with continuous banner
 mode
Roll of banner paper (avoid perfo-
 rated, fanned sheets)
Roll of Con-Tact paper
Permanent spray adhesive
Scissors
Ruler

Instructions
Follow steps 1–6 under "Making Banner-Printed Borders" on page 23.

LINENS

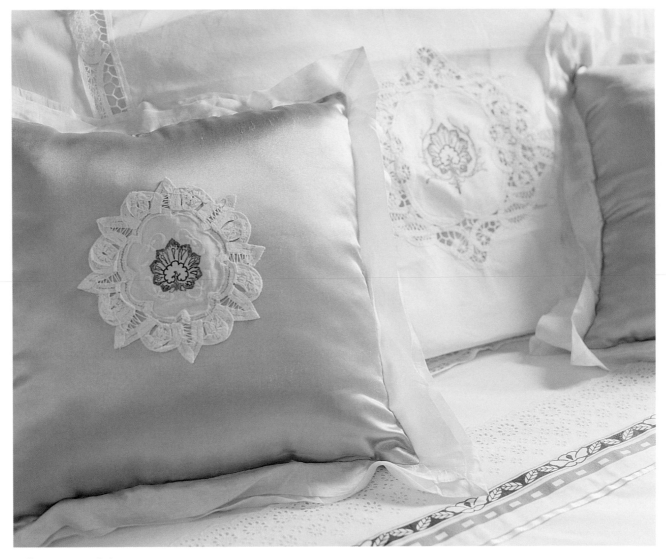

Pillowcases and shams

For practically foolproof transfers onto cotton, silk, and linen, choose spot designs or stand-alone motifs in a variety of colors, such as those on the pillowcases, shams, and dust ruffle. Repeat-ing patterns, especially those with solid colors, are more difficult. To reduce the appear-ance of visible joints in a continuous solid-color border, I allow a margin so that I can overlap and tape the printouts together at each end. (See "Using Heat Transfers," step 2, on page 28 for details.) This method works better than butting two trimmed edges. It takes practice, but as you can see in the photo of the pillow-case and top sheet (next page), the finished look is fabulous.

I also like transferring images onto lace or

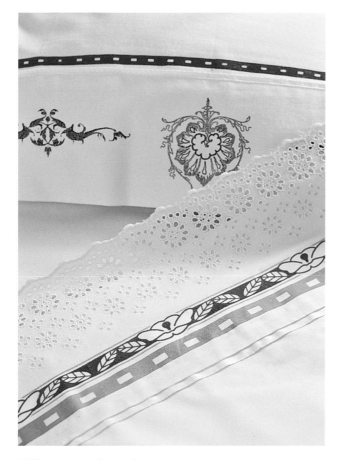

Pillowcase and top sheet

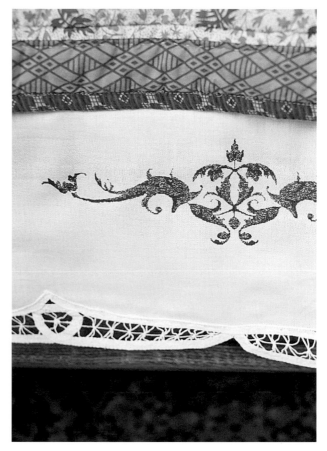

Dust ruffle

doilies and then attaching these to my purchased linens. It provides a different look (notice the mint satin decorative pillows), and I don't risk accidentally scorching the main item. Wide lace trim works well on top sheets. Since heat transfers don't wash well over time, you can always replace the lace itself, at only a few dollars a yard, rather than discarding a costly top sheet before ordinary wear warrants.

Materials
Inkjet heat-transfer sheets
Bed linens, window treatments, etc.
Doilies and/or wide lace trim
Iron
Fusible tape or sewing machine
Scissors
Ruler
Tape

Instructions
Follow steps 1–5 under "Using Heat Transfers" on page 28.

- For the most forgiving transfers, choose spot designs or stand-alone motifs in a variety of colors.
- For a continuous solid-color border, tape the transfer printouts together as described in step 2.
- Remember to reverse-print monograms and other lettering.
- Experiment with transferring images to doilies or lace trims. Fuse or sew the finished lace to purchased linens or pillows.

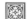

TABLE LAMP

I could have used a heat transfer to produce this lampshade's motif. Long-term exposure to the lamp bulb is not likely to make a transfer crackle or even lift from the fabric. But to avoid even the remotest possibility, I decided to print directly onto fabric instead—my own fabric, specially prepped to run through the printer. For best results on a small-carriage printer, choose a shade that measures 3½" x 9½" x 6" or less. The lamp should have a smooth ceramic, glass, or plastic base to accept the coordinating decal.

Materials

Small table lamp with shade

For lampshade only:

½ yd. light-colored nonstretch fabric

Ribbon trim or other embellishments (optional)

Fusible tape or sewing machine

Fabric glue

Fabric-basting spray

Iron

Scissors

Pins

Tape measure

Pencil

8½" x 14" or larger light card stock (to fit your printer carriage)

Tracing paper or newsprint

Tape

For base only:

Xerox "Color Inkjet Window Decals"

Art-fixative spray

Acrylic spray sealer for ceramics

X-Acto knife

Scissors

Ruler

Alcohol pads

Scrap paper or cardboard

Paper towels

Instructions

Lampshade

Note: Refer to "Direct Media Printing" on pages 34–36.

1. Make a pattern of your lampshade: Lay the shade, seam side down, on tracing paper and roll it one complete revolution, marking the top and bottom edges with a pencil as you go. A barrel shade will produce a rectangular pattern; a cone shade, a doughnut segment.

2. Extend the top, bottom, and one side edge of the pattern ⅝", for a fold allowance.

3. Iron the fabric smooth. Pin the pattern to it and cut out.

4. On the largest-size card stock your printer can handle, trace as much of the lampshade pattern as will fit. Make certain the area of the shade you wish to print falls within the printer margins.

5. Using your page-layout or graphics-editor software, create and size your design. Do one or more test prints on the marked card stock to verify the position.

6. Apply basting spray to the card stock, staying within the shade outline as much as possible (you don't want to gum up the print heads). Iron the cut lampshade fabric once again, then smooth it into position on the card stock. It must lie perfectly flat. Tape down every edge of the fabric. Fold any extending fabric to the underside and tape down.

7. Run this layered piece through your printer to transfer the design to the lampshade fabric.

8. Carefully remove and discard the tape and the card stock. Press the top and bottom curved edges ¼" to the wrong side, easing the curves. Fuse with iron-on tape, or machine stitch.

9. Apply basting spray to the original lampshade. Wrap the printed fabric around the shade. Overlap and glue the straight edges. Fold and glue down the top and bottom edges. Add ribbon trim or other embellishments if desired.

Base

For a permanent finish, follow steps 1–7 under "Making Decals" on pages 20–21. Consider the shape of your lampshade base when choosing an image. If the design is large, it may not lie flat on a curved surface.

Family Room Collection

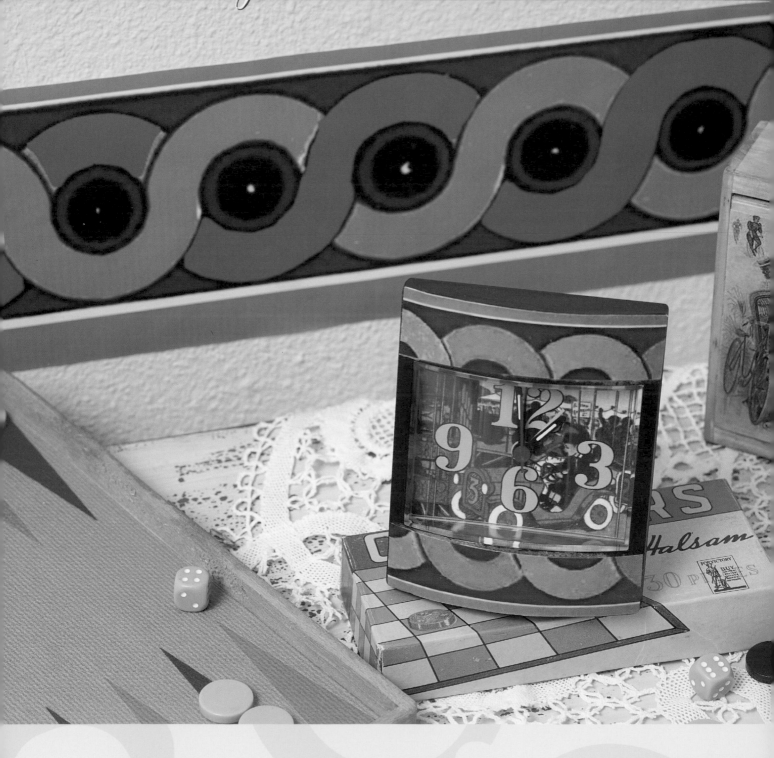

To CREATE ACCENTS AND ACCESSORIES for a room that's already furnished, you'll want to tap into the room's existing personality. This family room offsets its modern conveniences with a vintage entertainment theme. The colors alone take you back to a simpler time—helping today's families to unwind.

WALLPAPER BORDER

This border's intertwined colors and Art Deco style lend historical authenticity to the family room's decor. The design reminds me of the old Radio City Music Hall and its upstairs Rockefeller Center neighbor, the Rainbow Room, before their makeovers.

Materials
Printer with continuous banner mode
Roll of banner paper (not perforated, fanned sheets)
Roll of Con-Tact paper
Permanent spray adhesive
Scissors
Ruler

Instructions
Follow steps 1–6 under "Making Banner-Printed Borders" on page 23.

BURNISHED CHAIR RAIL

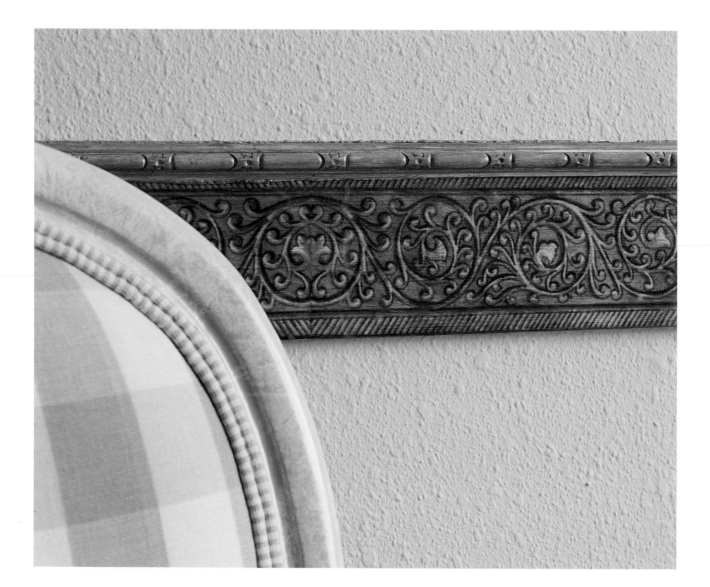

Chair rails add interest to otherwise plain walls, especially if they have burnished designs that coordinate with the other furnishings in the room. The chair rail featured here is assembled from a flat board and a strip of decorative molding, which forms the top lip. The continuous design is burnished on the flat board only, and the molding is painted and glued on afterwards. Practice your burnishing technique and paint finish on some scraps first to be sure that the finished colors on the two pieces work well together.

Materials

Access to color photocopier *or*
 sublimated-dye inkjet printer
Flat board, ¼" x 3½" x desired length
Decorative molding, ½" x ⅜" x desired length
Wood stain, paint, and/or sealer
Velcro tape or finishing nails and hammer
Wood glue
Wood-burning tool with flat tip
Iron
Miter box
Handsaw
Clamps
Scissors
Ruler
Tape

Instructions

Note: Refer to "Using Color Burnishing" on page 31.

1. In your page-layout program, working in landscape mode, size your image to fit within a 3" board width, to allow for the top-lip trim. Butt as many repeating images on-screen as possible up to the maximum page length your printer will allow. Fit as many strips per page as possible. Calculate how many pages of border strips are required to fill your total board length.

2. Print the required pages using sublimated dyes. Or print one page, then make the required number of color photocopies at a copy center.

3. Cut your border strips apart. Align the short ends, then tape together on the wrong side to yield the required length.

4. Preheat the iron and the wood-burning tool at their highest settings for more than 15 minutes. Tape the border strip, facedown, to the chair-rail board. Set the hot iron on the first 5" to 6" of the border strip and press down firmly for a few seconds. Now go over the same area with the hot wood-burning tool. Carefully lift the end of the strip to check your work. Reposition the pattern and reheat any areas too light in color.

5. Continue to burnish the design along the entire length of the board. Remove all the paper and tape. Continue on any additional boards, starting the pattern where the previous board left off.

6. Finish the decorative molding as desired with stain and/or paint and sealer. I rubbed in green paint, followed by gold paint. Then I rubbed a light wood stain over the molding, removing some of the stain while it was still wet. This technique produced a distressed finish that coordinated well with the burnished transfer.

7. Glue the decorative molding to the top of the chair rail, clamp securely, and let dry overnight. Lightly varnish the entire chair rail, following the manufacturer's instructions. Let dry overnight.

8. Attach the finished rail to the wall using Velcro tape or finishing nails. Miter the corners and butt the ends of adjoining pieces so the design continues uninterrupted. You can also hide the joins with decorative corner blocks, finished as described in steps 6 and 7.

FIREPLACE SCREEN

This fun, stylish screen was a cinch to produce. I simply blew up a clip-art image that suited the room's decor, cut it apart into three panels, and mounted them inside purchased picture frames. The frames are hinged together so you can see the whole picture.

Materials
Three 12½" x 22½" picture frames with mats
Four 1" x 1" hinges
Drill
Screwdriver
Scissors
Ruler

Instructions

Note: Refer to "Poster-Size Wall Prints" on page 88 for printing alternatives.

1. Measure the mat opening, for example, 8" x 17½". Add 1" to each measurement. Multiply the new width by 3 to obtain the total image size, for example, 27" x 18½".

2. In your page-layout or graphics-editor software, enlarge your selected image to the dimensions calculated in step 1. Divide the picture into 3 equal sections and print each one. If the size is too large for your printer to handle, use the software's tiling option and piece the image together. You can also have the file professionally printed at a copy center.

3. Mount the picture printouts in the frames.

4. Hinge the frames together along the side edges to make a standing triptych. Be sure to keep the pictures in sequence.

MAGAZINE STAND

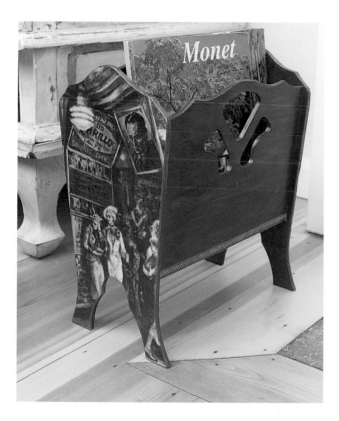

Do you recognize the picture on the end panel of this old magazine stand? It is the same one used in the fireplace screen. Additional printouts of the chair-rail trim are decoupaged to the bottom edge of the front and back panels. Subtle bronze highlights add a soft shimmer at night. I made them by streaking a nearly dry brush over the surface, to add just a hint of metallic shine.

Materials

New or used magazine stand with flat sides
Bronze acrylic craft paint
Art-fixative spray
Varnish
White glue
Foam brushes
Scissors
Pencil
Tracing paper or newsprint
Paper towels

Instructions

Note: Refer to "Making Decoupage Designs" on page 18.

1. Place the magazine stand on end on tracing paper or newsprint and make a tracing of each end panel.

2. Using your page-layout or graphics-editor software, size your image to fill the traced outline. Print the image on the unmarked side of the paper. Also size and print any trim strips you wish to add. Spray all the printouts with art fixative and let dry.

3. Cut out each large image along the marked outline. Glue the images to the magazine stand and let dry overnight. Seal the top and edges of each image with a thin coat of glue. (See "Making Decoupage Designs," steps 3–6, on page 18.)

4. Cut out the trim strips and glue to the bottom edge of the front and back panels, or as desired. I used a tiny trim design from the chair-rail border for my trim strips.

5. To add bronze highlights, dip brush in bronze paint, blot excess on paper towels until bristles are almost dry, then streak brush lightly over the decoupage surface.

6. Let the rack dry overnight, or longer if you live in a humid climate. Apply 2 or more coats of varnish, following manufacturer's recommendations.

BACKGAMMON GAME BOARD

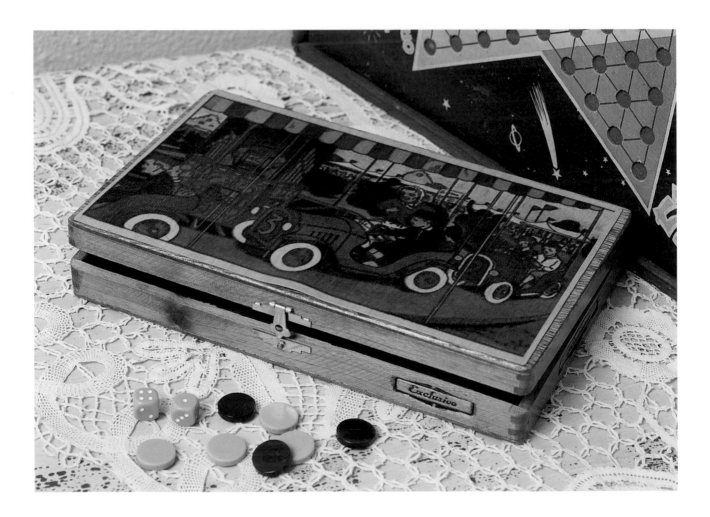

When I came up with the Digital Decorating concept several years ago, this was one of the first projects I sketched out. Finally, in the room geared for family enjoyment, I have the ideal spot to show off this simple, entertaining project.

Materials
Xerox "Color Inkjet Canvas Paper"
Empty wooden cigar box
Dice and game pieces
Wood veneer sheets
Varnish
Art-fixative spray
Glue or spray adhesive
Scissors
Ruler

Instructions
Note: Refer to "Direct Media Printing" on pages 34–36.

1. Measure the outside lid and the inside lid of your cigar box.
2. Using your page-layout or graphics-editor software, size a decorative image to fit the outside lid.
3. Cut a piece of wood veneer to this size plus a 1" margin all around. Print directly onto the wood veneer. (See the Tech Tip on page 35.) Spray with art fixative and let dry.
4. Use your software to draft a rectangle the same dimensions as the inside lid. Inside the rectangle, draft 12 identical elongated triangles—6 on each short edge. Choose 2 colors and assign them alternately to the triangles as shown.

5. Print 2 copies of the gameboard rectangle on canvas printer sheets. Spray with art fixative and let dry.
6. Trim the printed wood veneer and, using glue or spray adhesive, mount it on the outside box lid. Varnish and let dry, following the manufacturer's directions. Cut out and adhere the 2 game-board rectangles to the inside lid and the inside floor of the box. Varnish if desired. Store the dice and markers inside the box.

CROSS-STITCH FOOTSTOOL

I knew I'd stumbled onto something wonderful when I burnished this Shakespearean poster image onto a piece of cross-stitch fabric. I realized that finally needlepoint and cross-stitch artists had an alternative to buying kits at highway-robbery prices. Just the smallest and simplest hand-painted images start at around $40, and the prices go way up from there. This little image, which was quickly and expertly cross-stitched by my mother to meet this book's deadline, looked no less hand-painted than any of the patterns I've seen in needlepoint and cross-stitch stores.

Materials

Sublimated-dye inkjet printer
New or used footstool
Cross-stitch fabric
Embroidery floss and needle
Sewing thread and needle
Vintage iron
Sewing shears
Ruler
Transparent tape

Instructions

Note: Refer to "Using Color Burnishing" on page 31. To adapt this project to the heat-transfer method (page 28), follow the steps below with the following changes: In step 2, print the image on "hot" transfer paper; in step 4, trim with no margin; and in step 5, tape down only one edge and follow the manufacturer's instructions when ironing.

1. Cut a piece of cross-stitch fabric to the desired image size, adding a 2" margin all around.

2. Use your page-layout or graphics-editor software to size your image. Print with an inkjet printer on ordinary paper using sublimated dyes. Be sure to mirror-image your design if it includes words or numbers.

3. Preheat iron to the hottest setting for 15 minutes.

4. Meanwhile, cut out your printout, leaving a 1" margin all around.

5. Lay the image facedown on the fabric and tape down all the edges. Apply the vintage iron for a few seconds. Carefully lift the paper to check your work, and reheat any areas as necessary.

6. Cross-stitch the entire image or a portion of it, such as the border, by matching your floss color to the printed colors. Many designs also work as mock cross-stitch (see pillow on page 90).

7. Trim the margin to 1"; fold under and press. Center the embroidery on the footstool and sew in place.

ACCESSORIES

NOTEBOOK COMPUTER COVER

If you've still got a computer sitting in your living room for all the world to see, do yourself and your family a favor and find a nice cabinet to tuck it away in when not in use. Computers, like televisions and stereo equipment, are appliances, not furnishings. I'll give you a break if you put a small folding screen in front of your monitor once you close up shop. It will do wonders for your room's decor. Even notebook computers when closed still look like notebook computers. Give them a fashionable edge with a wood-veneer cover embellished with your monogram. It will make your notebook computer a much more stylish travel companion, as well.

Materials

Wood-veneer sheets (or plain paper)
Art-fixative spray
Glue or adhesive spray
Varnish
Scissors
Ruler

Instructions

Note: Refer to "Direct Media Printing" on pages 34–36.

1. Measure your notebook computer to determine the image size.
2. Cut a piece of wood veneer to this size plus a 1" margin all around.
3. Using your page-layout or graphics-editor software, size your image to your dimensions in step 1. Print onto the veneer (refer to the Tech Tip on page 35).
4. Trim the veneer even with the image all around.
5. Spray art fixative on the printout and let dry. Spray or brush on a protective coat of varnish or shellac, following the manufacturer's instructions. Let dry overnight.
6. Use glue or adhesive spray to mount the veneer on the cover of the notebook.

FRAMED "GRANDMA" PICTURE

A family room just isn't complete without family pictures. Among the photos in this room, the portrait of my grandmother, superimposed onto a vintage Hollywood scene, is especially fitting: Grandma Helyn happened to be one of the first ushers at the Grauman Chinese Theatre. I used a combination of airbrush and cloning tools in my graphics-editor software to create this surreal effect.

Materials
Picture frame
Photograph
Scanner
Scissors
Ruler

Instructions
1. Scan your photo.
2. Using your graphics-editor software, place your scanned-photo file atop another picture. I chose a clip-art file of an old Hollywood movie premiere poster. Using my software's airbrush and cloning tools, I merged the spotlights onto Grandma.
3. Size the composite file to fit your picture frame plus a ½" margin all around. Print the picture and mount it in the frame.

SMALL TABLE CLOCK

It's just a little accessory, but there's no reason why a table clock can't match the rest of the room. Two of the Family Room motifs are repeated here: The decorative lid of the backgammon box reappears on the clock face, and the wallpaper border, reduced in size and cut in half, is decoupaged to the clock housing. It all adds up to a playful timepiece in this Art Deco–inspired room.

Materials

New or used tabletop clock
Con-Tact paper
White glue
Art-fixative spray
Permanent spray adhesive
Foam brush
Scissors
Ruler

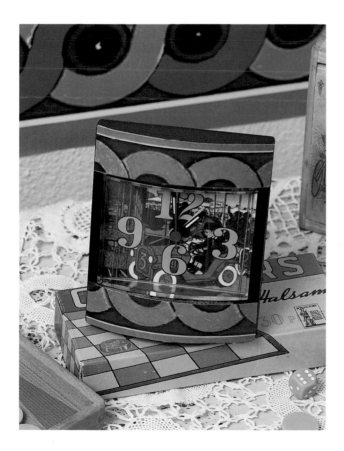

Instructions

Note: Refer to "Using Other Sticky Solutions" on page 26 and "Making Decoupage Designs" on page 18.

1. Carefully disassemble the clock so the face is exposed. Remove the clock hands. Measure the clock face and those areas on the clock housing that you wish to decoupage.
2. Using your page-layout or graphics-editor software, size one image to fit the clock face. Add clock-face numerals as desired. Size one or more coordinating images to decoupage to the clock housing.
3. Print all the images. Spray with art fixative and let dry.
4. Lay the Con-Tact paper, right side up, on a flat surface. Apply permanent spray adhesive, following the manufacturer's directions. Adhere the printed clock face to the Con-Tact paper.
5. Nip a hole in the center of the printed clock face to accommodate the clock workings.
6. Cut out the clock-face "sticker" through all the layers.
7. Peel off the Con-Tact paper backing and press the sticker in place on the clock. Reassemble the clock.
8. Decoupage the remaining images to the clock housing. (See "Making Decoupage Designs," steps 3–7, on page 18.)

VIDEO AND CD STORAGE LUGGAGE

You can buy expensive CD storage racks and media towers for your audio/video collection, but don't expect them to add any charm—or even true function—to your decor. For style to meet function, I turned instead to this set of old leather luggage, picked up at a garage sale for less than $2. The suitcase holds dozens of videos, and the overnight case does the same job for CDs. I added a few "vintage" stickers to increase the charm of both.

Materials
Old luggage
Con-Tact paper
Art-fixative spray
Permanent spray adhesive
Acrylic spray sealer
Scissors
Ruler

Instructions
Follow steps 1–6 under "Using Other Sticky Solutions" on page 26.

- Choose old-fashioned travel poster images and reduce them to postcard size for printing.
- Leave a narrow white border around each image when you cut it out to suggest an old-fashioned label. Adhere the stickers to the suitcases in a random way, as if they were slapped on quickly en route.
- Spray several coats of art fixative on the stickers to protect them from normal wear—especially if you will be using your luggage in a family room.

SMALL DECORATIVE BOX

In days gone by, a tabletop box might have held cigarettes or smoking accessories. Today, small decorative boxes can be just as functional. Use them for candy dishes, paper-clip holders, computer diskettes, or notepads and pencils. Don't forget that they also make great gift boxes when filled with loose tea, cookies, or nuts.

Materials
Wood box
Acrylic craft paint
White glue
Art-fixative spray
Varnish
Foam brushes
Scissors
Ruler

Instructions

Note: Refer to "Making Decoupage Designs" on page 18.

1. Paint the box as desired. (I brushed on a dusty green paint for an antique appearance.) Let dry.

2. Measure the box lid or other area to be decoupaged.

3. Using your page-layout or graphics-editor software, size the image to fit the box lid and print it. Spray with art fixative and let dry.

4. Cut out the image and glue it to the box lid. Let dry overnight. Seal the top layer and edges with a thin coat of glue. (See "Making Decoupage Designs," steps 3–6, on page 18.)

5. Let the box dry overnight. Apply 2 or more coats of varnish, following manufacturer's recommendations.

Bathroom Collection

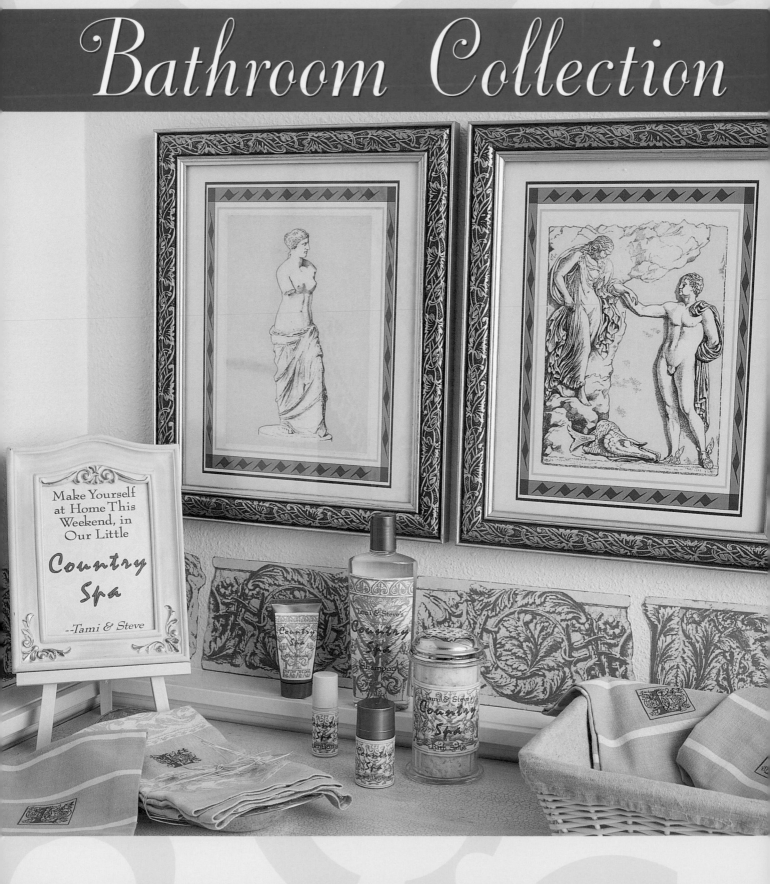

Make Yourself at Home This Weekend, in Our Little

Country Spa

-Tami & Steve

THE RIGHT ACCESSORIES CAN TRANSFORM

an ordinary bathroom into an indulgent getaway. With Digital Decorating, you can make the transition affordable by using accessories you already own. Adorn a plain fabric shower curtain, cover an existing wastebasket, embellish everyday hand towels. You can even imitate marble and other stones with paper, as I've done in making this room's unique border treatment. Just pick a theme and an anchoring color scheme. The resulting style is all your own.

DECOUPAGE STONE BORDER

Each of the room collections in this book includes a border treatment. To demonstrate yet another Digital Decorating technique, I created individual faux chiseled stones in my Country Spa bath. The stones' special decoupage finish gives them a polished appearance while making them resistant to a bath's normal humidity. Such stones could be decoupaged directly to a wall, but I chose to give them a sticky back so they will be easy to remove when I'm ready to change the decor.

Materials
Con-Tact paper
Art-fixative spray
Permanent spray adhesive
Acrylic spray sealer
Scissors

Instructions
Follow steps 1–6 under "Using Other Sticky Solutions" on page 26.

- Select two or three different stone images. Make each stone as an individual sticker. To add variety, print some stones in mirror image.
- Apply four or more coats of acrylic spray if you plan to use your stones in a bathroom.

FRAMED PICTURE PAIR

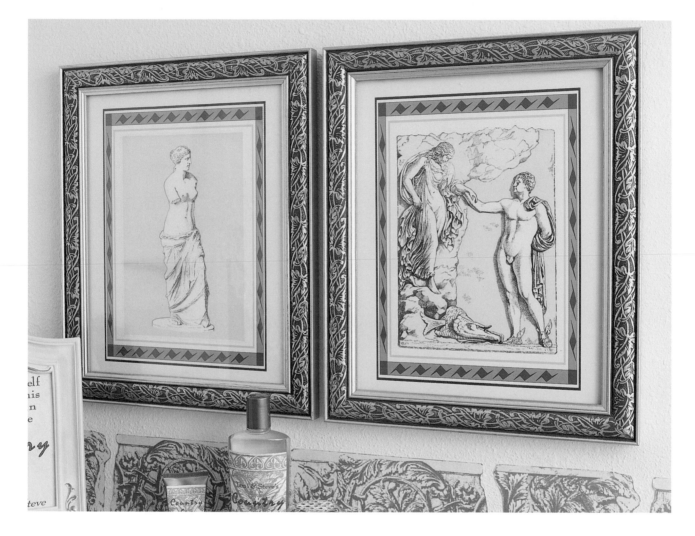

What spa is complete without a Roman statue or two? Hence, the picture pair I chose to frame for the walls of my Country Spa. I just happened to find a wonderful set of about a dozen similar statues in a clip-art library, all perfectly coordinated to this room's decor. If my room had a different color scheme, I could have instantly changed the pale yellow background to another color. Such is the classical beauty of Digital Decorating. Don't forget, decoupage picture groups can also be mounted directly on the wall in an au courant print-room style.

Materials

Picture frames
Art-fixative spray
Scissors
Ruler

Instructions

Size your selected art to fit your picture frame mat opening plus ½" extra all around. Print the images and spray with art fixative. Mount in the frames.

WASTEBASKET

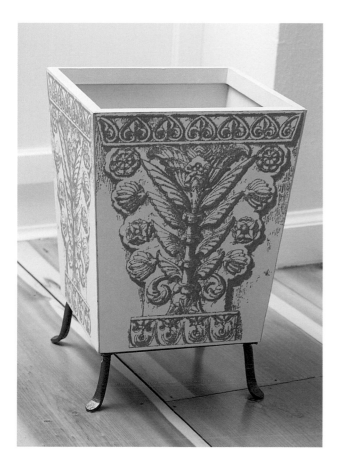

Whether it's a wooden square, an oval tin, or ordinary plastic, any wastebasket can get a designer look with digital printouts. This particular model's tapered silhouette presented a unique challenge, but once I started seeing it as an architectural fragment I couldn't imagine a better piece to work with. Considering the amount of customization involved—sizing each panel perfectly to the basket's dimensions, reversing two images to make all the corners meet, and then creating the yellow-gray-tan palette to go with the faux-stone border—I also couldn't imagine doing it without Digital Decorating!

Materials

New or used square tapered wastebasket
 (wood, plastic, or metal)
Permanent spray adhesive
Art-fixative spray
Acrylic spray sealer
Scissors
Ruler

Instructions

Note: Refer to "Making Decoupage Designs" on page 18.

1. Measure an exterior side of the wastebasket.
2. Using your page-layout or graphics-editor software, size one image to fit the side of the wastebasket. The downward taper of this wastebasket suggested an architectural capital to me, and I found a corresponding image in a clip-art file.
3. Print 2 images, then print 2 more images in reverse, using the mirror-image feature on your printer software.
4. Cut each printout to fit a side of the wastebasket.
5. Adhere the printouts to the wastebasket with permanent spray adhesive, following the manufacturer's instructions. For a "seamless" join, alternate the regular and mirror-image printouts so the patterns meet at the side edges.
6. Spray all surfaces with a heavy coat of art fixative. Let dry.
7. Apply 2 coats of acrylic spray sealer, following the manufacturer's directions.

CUSTOM TOILETRIES

Don't just tell your weekend guests to make themselves at home; make them *feel* comfortable and welcomed. Your home will feel like a special bed-and-breakfast country inn when you set out a ready supply of fresh towels and these custom toiletries. Buy small sample-sized toiletries, or use those extra hotel amenities you packed home from your last trip, then give them your own special "spa" labels.

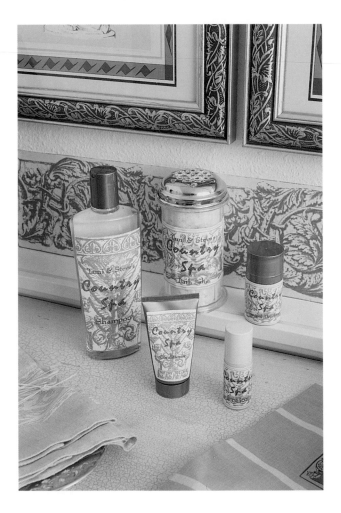

Materials

Small bottled or packaged toiletries (soaps, lotions, shampoo)
Grated-cheese shaker (for bath salts)
Lightweight cotton fabric
Ribbon or raffia
Con-Tact paper
Art-fixative spray
Permanent spray adhesive
Acrylic spray sealer
Inkjet heat-transfer sheets
Iron
Scissors
Ruler

Instructions

Follow steps 1–6 under "Using Other Sticky Solutions" on page 26 to make a label for each toiletry container. Follow steps 1–5 under "Using Heat Transfers" on page 28 to make a printed fabric wrapper for each bar of soap.

- Decide on a theme or a special design for your labels. I chose "Country Spa" to go with the casual Roman motifs in this bath.
- To package soap bars, wrap the printed fabric around them and tie with ribbon or raffia.
- Load the grated-cheese shaker with bath salts.
- Put a Digital Decorating welcome sign in a picture frame (see page 74).

LINENS

The pattern adorning the bath's shower curtain and tiebacks (see pages 80 and 81) is perhaps my favorite, not just for its design but also for the effect it took on once it was transferred. I started with a clip-art file of an old wallpaper border. I stripped out its background, leaving only the design element you see, and then changed the color palette to the yellow, gray, and tan tones prominent in the room. Because I chose not to fix blotchy, shaded areas that existed in the original clip-art file, they became even more prevalent with the palette change. Once I transferred the images to fabric, they took on a batik quality. The result is simply a work of art, and certainly one-of-a-kind. The monogram on the guest towels was also modified from a clip-art file to match the room's decor.

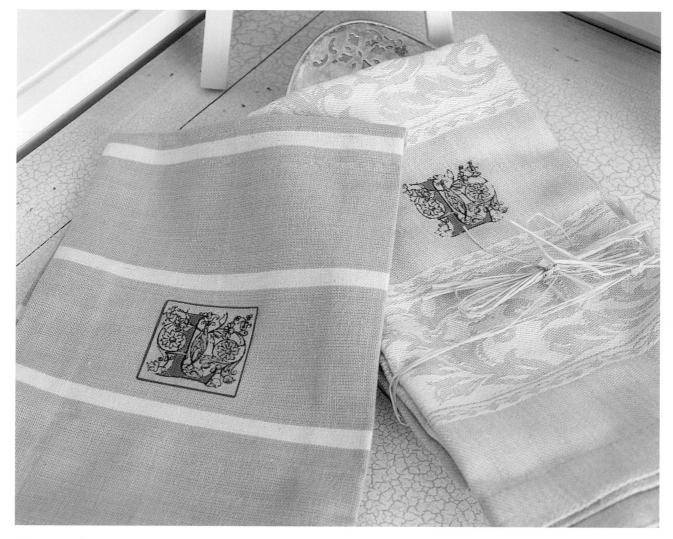

Guest towels

Materials

Bathroom linens (shower curtain, curtain
 tiebacks, guest towels, muslin-covered
 baskets)
Inkjet heat-transfer sheets
Iron
Scissors
Ruler

Instructions

Follow steps 1–5 under "Using Heat Transfers"
on page 28 for each item.

- Choose "hot" or "cold" transfers, depending
 on the item.
- To avoid an obvious join line in the
 tiebacks' mingled color borders, don't
 clean-cut the transfer ends and don't tape
 them. Instead, just transfer each section to
 the tieback by eye as you go along.

Shower curtain

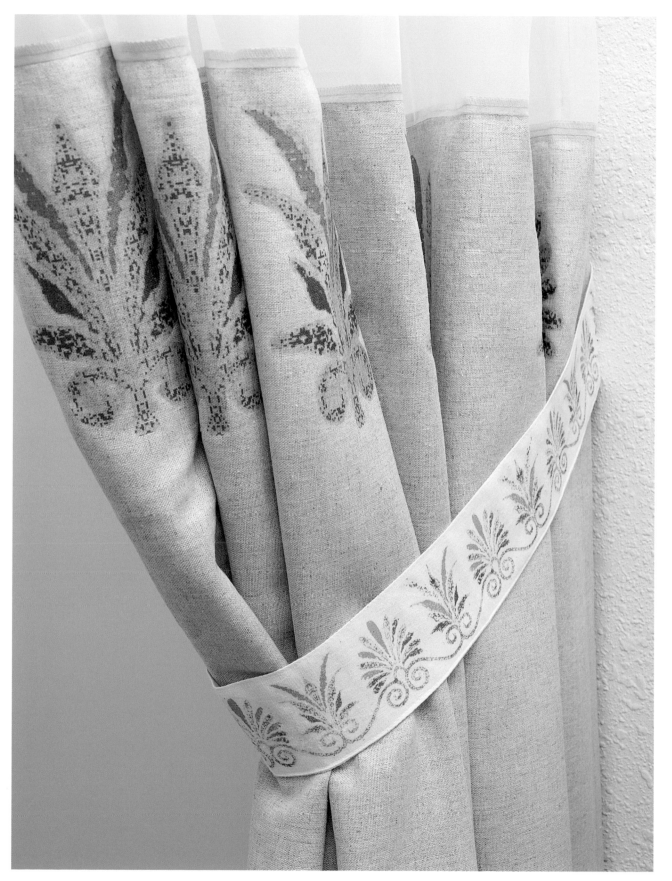

Curtain tiebacks

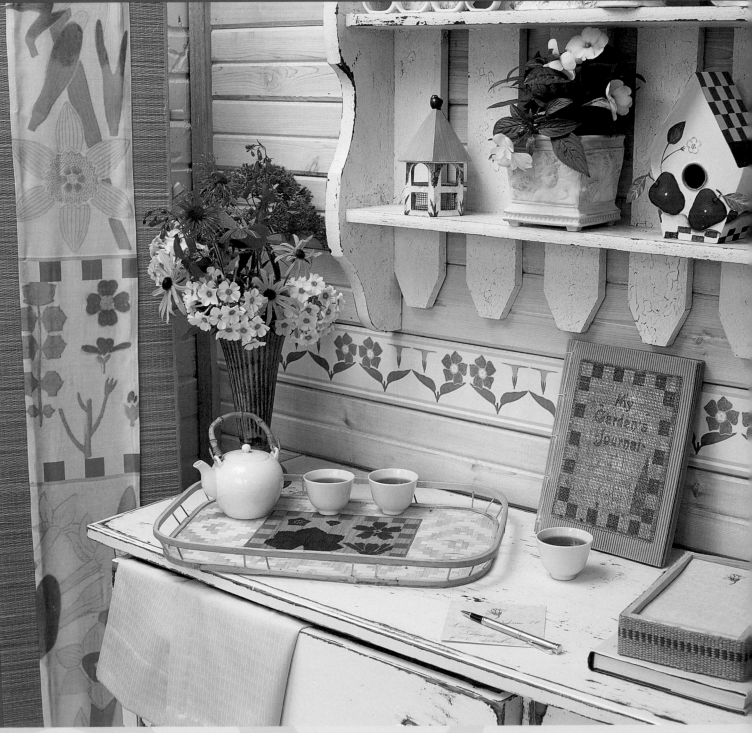

HOW DO YOU MAKE AN ASIAN-INSPIRED

folding screen and serving tray work with cross-stitch pillows, pop-art posters, and country-style checks? With Digital Decorating, of course! It's the perfect way to achieve eclectic balance, as you control the designs and color schemes that pull everything together. This room's understated flora, lemon-lime backdrops, and periwinkle accents all add up to cozy, eye-pleasing style.

WALLPAPER BORDER

This cheerful border was printed on continuous banner paper. The breaks between the motifs make this design easy to adapt to segment printing as well. For an example of a border printed in segments, see page 23.

Materials

Printer with continuous
 banner mode
Roll of banner paper (not
 perforated, fanned
 sheets)
Roll of Con-Tact paper
Permanent spray
 adhesive
Scissors
Ruler

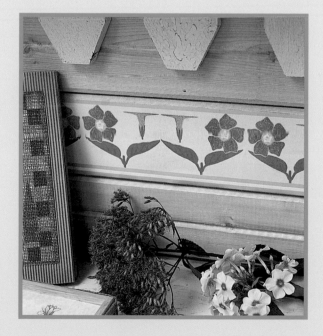

Instructions

Follow steps 1–6 under "Making Banner-Printed Borders" on page 23. If your printer does not support continuous banner printing, follow steps 1–6 under "Making Segment-Printed Borders" on pages 23–24.

FLOOR TREATMENT

There are so many ways to create your own rugs and floorcloths. You can buy heavy cotton duck canvas at a fabric store, cut it to size, and add painted or stenciled designs or heat transfers. Many craft stores sell precut, preprimed canvas that's ready to stencil or paint. Unfortunately, preprimed surfaces don't accept iron-on transfers as well as noncoated fabric. To get around this problem, I simply turned over an old rug of mine and created a whole new one! If it's a floorcloth you want, make your own from scratch using unprimed canvas. But to adorn your floor a simpler way, take the route I did.

Materials
Solid-color woven fabric or rag rug

For color burnishing:
Access to color photocopier *or* sublimated-dye inkjet printer
Flat-tipped wood-burning tool, vintage iron, or professional (400°F) iron

For heat transfer:
Inkjet heat-transfer sheets
Art-fixative spray
Spray polyurethane (optional)
Iron

Instructions
Follow steps 1–5 under "Using Color Burnishing" on page 31 or steps 1–5 under "Using Heat Transfers" on page 28.

- Choose a spot design, a border pattern, or both for your rug.
- Fit as many spot designs as will print on the largest-sized paper your printer can handle (8½" x 11" for most manufacturer's heat-transfer sheets). Split big motifs, such as the flowers shown here, into smaller units and transfer them in stages, much as you would a border. Transfer a checkered pattern block by block.
- When color burnishing, monitor your vintage iron's heat setting carefully. Most older irons will scorch a cotton rug. Practice before working on the actual project.
- Seal "hot" heat transfers with a light coat of art fixative followed by a light coat of polyurethane spray. Use heavier coats on "cool" transfers. Sublimated dyes do not require this protection.

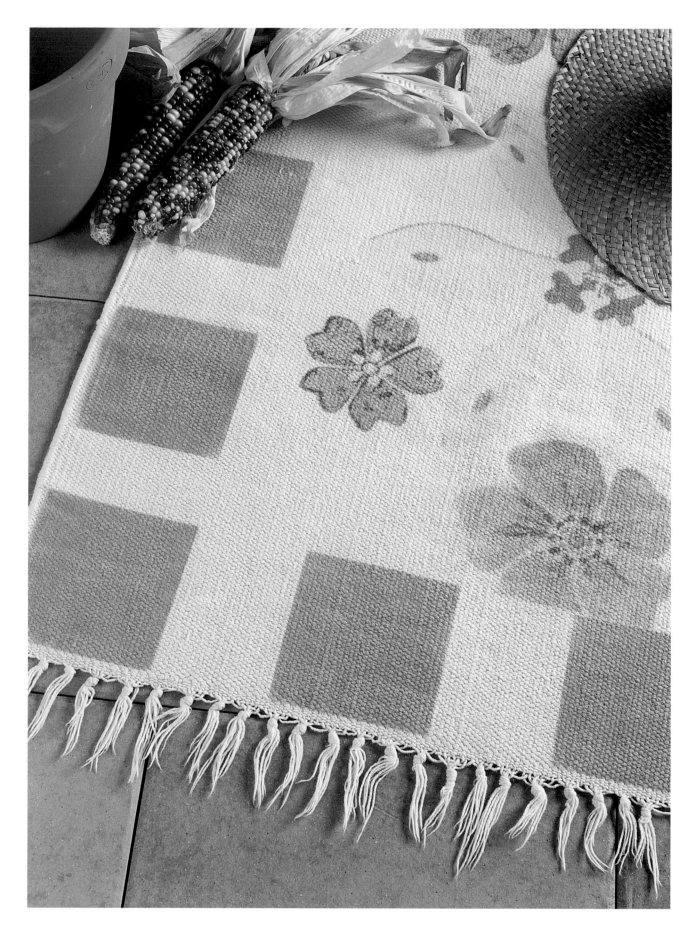

FOLDING SCREEN

This Asian-inspired screen exemplifies perfectly how unconventional materials can be transformed into a traditional home furnishing. The individual components include three ordinary garden trellises, less than $10 each at the garden center; a $5 grass beach mat from Pier I Imports; and bark-textured tree wrap, used to trim the upper and lower edge of each panel. The design is banner-printed on silk fabric from Jacquard Products (see "Sources and Credits" on page 92 for buying information).

Materials

Printer with continuous banner mode
3 wooden garden trellises, 15" x 71"
8½"-wide roll of Jacquard inkjet silk
 (or other printer-ready fabric)
36¾" x 66½" woven-grass beach mat
Roll of 4"-wide tree wrap
Iron-on tape or sewing machine
Upholstery tacks
Ten 1" x 1" hinges
Drill
Screwdriver
Hammer
Scissors
Ruler

Instructions

Note: Refer to "Direct Media Printing" on pages 34–36.

1. Using the banner mode of your page-layout or graphics-editor program, compose and size your floral design to fit along the length of one trellis (my banners are 8½" x 66½"). Print 2 banners on the inkjet silk. Machine-stitch a narrow hem along the long edges of the silk or finish with iron-on tape.

2. Multiply the trellis width by 6. Cut a length of tree wrap to this length. Banner-print a stripe design on it. (I used the same green stripe found in this room's wallpaper border.)

3. Cut the tree-wrap banner into 6 equal pieces. Cut the grass mat into 3 separate panels.

4. Lay one trellis flat. Lay a grass panel on top. Place a tree-wrap strip over each raw edge, top and bottom, to conceal it. At each end, press upholstery tacks through the tree wrap and mat into the trellis wood; tap in with a hammer if necessary. Repeat this step with the remaining panels, but overlay the silk banners on the grass panels and secure them all together.

5. Using a zigzag fold, hinge all three panels together.

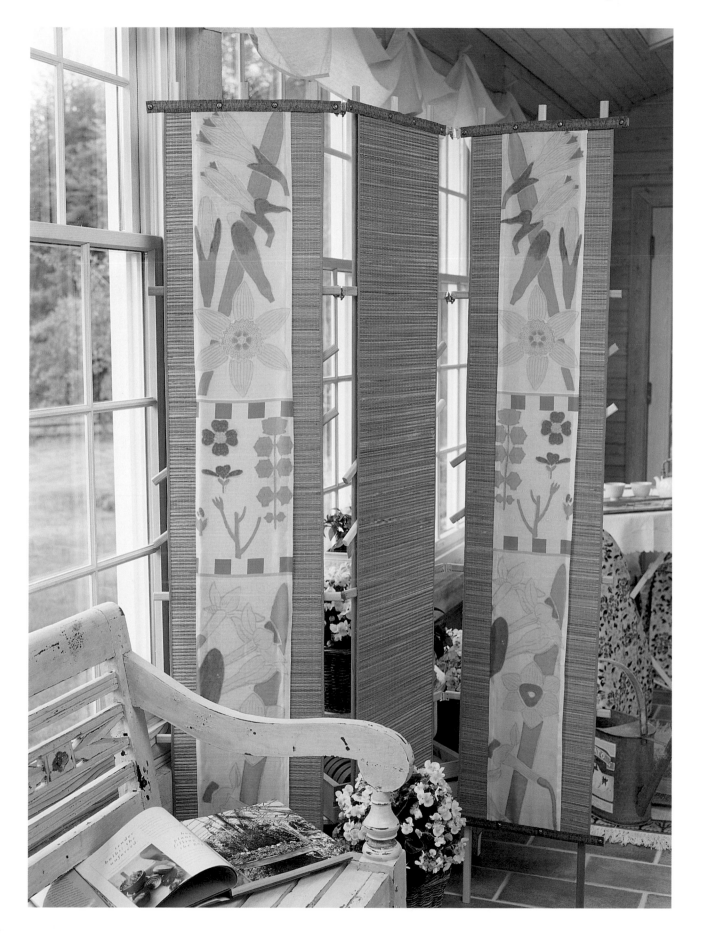

POSTER-SIZE WALL PRINTS

Even though most page-layout and graphics-editor programs can print poster-size pictures, few home printers can handle paper larger than 8½" x 14", much less 11" x 17" or a larger tabloid-size. Your software's tile option is one way to get around this limitation, but for a more professional output, take your files to a copy center like Kinko's (a certified Hewlett-Packard print center) and have them blown up and printed on high-quality paper. Prices vary, but expect to pay around $30 for a poster-size print. Make the final product a real bargain by using $5 frames in bold colors from a home store such as IKEA. (For further information, see "Sources and Credits," page 92.)

ACCESSORIES

SERVING TRAY AND GARDENER'S JOURNAL

Whenever possible, I prefer printing directly onto a project's surface. Images are always crisp; colors, deep and vibrant. Find sheets and rolls of wood veneer—like that on this serving tray—at home-improvement stores. The stiff, canvas-backed burlap used in the gardener's journal is available in fabric stores.

Materials

Wood veneer sheets or stiff, canvas-backed burlap
Glue or spray adhesive
Art-fixative spray
Varnish
Scissors
Ruler

Instructions

Note: Refer to "Direct Media Printing" on pages 34–36.

1. Measure the area on your serving tray or journal to be covered.
2. Using your page-layout or graphics-editor software, size a decorative image to cover this area.
3. Cut a piece of wood veneer or stiff canvas to this size plus a 1" margin all around. Print directly onto wood veneer or canvas. Be sure to set the printer to manual or straight-through printing if you have the option, and mirror-print the image if it has words or numbers.
4. Trim the veneer or canvas to its final size. Spray with art fixative and let dry.
5. Varnish the finished piece and let dry, following the maufacturer's instructions. Glue to serving tray or journal.

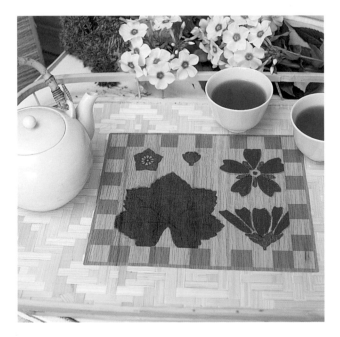

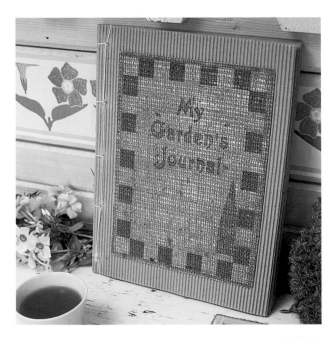

MOCK CROSS-STITCH PILLOW

The fine weave of cross-stitch fabric gives transferred images a threaded illusion. Cross-stitch just portions of a transferred image for aesthetic texture, or leave unadorned for an entirely mock look, as shown here.

Materials

Sublimated-dye inkjet printer
Cross-stitch fabric
Pillow
Needle and thread
Fabric glue
Vintage iron
Scissors
Ruler

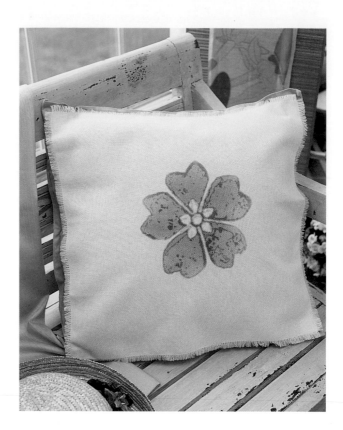

Instructions

Note: Refer to "Using Color Burnishing" on page 31. To adapt this project to the heat-transfer method (page 28), follow the steps below with the following changes: In step 2, print the image on "hot" transfer paper; in step 4, trim with no margin; and in step 5, tape down only one edge and follow the manufacturer's instructions when ironing.

1. Cut a piece of cross-stitch fabric appropriate to your use. If you'll be attaching the final product as a decorative panel to an existing pillow, allow for a turned-under edge and/or a decorative trim or, as I've done here, leave just enough for a frayed edge.

2. Use your page-layout or graphics-editor software to size your image. Print with an inkjet printer on ordinary paper using sublimated dyes. Be sure to mirror-image your design if it includes words or numbers.

3. Preheat the iron to hottest setting for 15 minutes.

4. Meanwhile, cut out your printout, leaving a 1" margin all around.

5. Lay the image facedown on the fabric and tape down all the edges. Apply the vintage iron for a few seconds. Carefully lift the paper to check your work, and reheat any areas as necessary.

6. Hand-sew or glue the finished piece to the pillow front. Leave the edges frayed, as shown, or turn under and embellish with decorative trim.

PERSONAL STATIONERY

Now more than ever, handwritten notes on beautifully adorned paper make lasting, personal impressions. Instead of ordering costly custom-printed notepaper (which is never quite truly custom, as the same product lines are available to others), use your computer to design your own. Sets like the floral notes shown here, packaged with a pen and tied with a ribbon, make wonderful gifts.

Materials
Shallow wooden box
Paper, cut to fit box*
Matching envelopes
Pen
Burlap ribbon (to fit around box)
Satin ribbon
Glue
Scissors

Many copy centers will cut their papers exactly to your specifications.

Instructions
1. In your page-layout or graphics-editor software, size your desired image and/or monogram and position it as you want it printed on your stationery.

2. Do a test print to check the position, then print directly onto the stationery for the number of copies desired.
3. Glue the burlap ribbon around the box's outer edge, trimming as necessary. Let dry.
4. Place the envelopes and stationery in the box. Tie a satin ribbon around the box. Tuck a pen under the ribbon.

Sources and Credits

Acer
800–SEE–ACER
www.acer.com
(home computers, scanners)

Adobe
888–724–4508
www.adobe.com
(clip art, page-layout and image-editing
software)

Apple Computer
800–MY–APPLE
www.apple.com
(home computers, inkjet printers, scanners, page-
layout and image-editing software, professional
color-matching tools)

Art.com
888–287–3701
www.art.com
(online lithographs and posters for custom framing)

Austin-James
800–426–3728
www.hanes2u.com
(clip art, page-layout and image-editing software,
inkjet transfer papers and supplies)

Avery Dennison
800–462–8379
www.avery.com
(inkjet papers, transfers, ready-to-print
magnets, labels, and stickers; free clip-art and soft-
ware downloads)

Broderbund
800–358–9144
www.broderbund.com
(clip-art libraries, software for page layout and pub-
lishing, photo/graphics editing, virtual home and
landscape design)

Canon
800–OK–CANON
www.canon.com
(inkjet printers, digital cameras, scanners,
specialty inkjet papers and transfers)

Canson Talens
413–538–9250
www.canson.com
(specialty inkjet papers, including sticky-back light
card stock)

CDW Software Warehouse
800–836–4239
www.cdw.com
(name-brand home computers, inkjet printers, scan-
ners, digital cameras, clip art, page-layout and
image-editing software, reference books)

Compaq
800–888–0220
www.compaq.com
(home computers, inkjet printers, scanners)

CompUSA
800–563–9699
www.compusa.com
(name-brand home computers, inkjet printers and
papers, scanners, digital cameras, clip art, page-layout
and image-editing software, reference books)

Conde Systems
800–826–6332
www.conde.com
(professional color-transfer systems, sublimated-dye
inkjet printers and supplies)

Corbis
800–260–0444
www.corbis.com
(clip art, online greeting cards, lithographs and posters
for custom framing)

Corel
800–772–6735
www.corel.com
(clip art, page-layout and graphics-editing software)

Custom Works in Wood
Timberline Home Products
tel. fax: 81–52–878–3490 (Japan)
(designer kitchen accessories, home furnishings,
custom cabinetry)

Dell
800–915–3355
www.dell.com
(home computers)

Epson
800–873–7766
www.epson.com
(inkjet printers, digital cameras, scanners, specialty
inkjet papers, including transfers and canvas banner
rolls)

Gateway
800–846–4208
www.gateway.com
(home computers)

Geo Knight & Co.
800–525–6766
www.geoknight.com
(professional color-transfer supplies and presses)

Hammermill Paper
www.hammermillpaper.com
(array of printing papers; visit Web site for a free sub-
scription to company's print-tips magazine, *Results*)

Hewlett-Packard
888–999–4747
www.hp.com
(home computers, inkjet printers, scanners, digital
cameras, specialty inkjet papers and transfers)

Hewlett-Packard Certified Poster-Print Centers
www.hpcpc.com

IBM
800–IBM–4YOU
www.ibm.com
(home computers, inkjet printers, scanners)

IKEA
800–434–IKEA
www.ikea.com
(home furnishings, many ideal for Digital Decorating)

International Textile Sourcing
212–391–6365
intextile@aol.com
(couture fabrics for home furnishings)

Jacquard Products
800–442–0455
www.jacquardproducts.com
(dozens of ready-to-print inkjet fabric rolls; silks,
wools, linens, cottons, and satins in assorted textures
and embossed designs)

Jasc Software
800–622–2793
www.jasc.com
(assorted page-layout and graphics-editing software,
many available for download trial)

June Tailor
800–844–5400
www.junetailor.com
(ready-to-print muslin fabric sheets)

Kinko's
800–2–kinkos
www.kinkos.com
(cut-to-size blank stationery, HP-certified poster
printing service)

Kodak
800–235–6325
www.kodak.com
(digital cameras, scanners, photo printers, writeable
CD products, image-editing software)

Macmillan Publishing
800–545–5914
www.mcp.com
(clip-art libraries and assorted software for virtual
home and landscape design)

Made to Order
877–742–5686
www.madetoorder.com
(professional custom-logo merchandise, using your
own images)

Martha by Mail
800–950–7130
www.marthabymail.com
(home furnishings, many ideal for Digital Decorating)

Michael's
972–409–1300
www.michaels.com
(arts and crafts supplies)

Microsoft
800–426–9400
www.shop.microsoft.com
(clip art, page-layout and image-editing software,
reference books)

Microtek
800–scanall
www.microtek.com
(scanners, image-editing software)

Office Depot
888–463–3768
www.officedepot.com
(name-brand home computers, inkjet printers and
papers, scanners, digital cameras, clip art, page-layout
and image-editing software, reference books)

Office Max
800–283–7674
www.officemax.com
(home computers, inkjet printers and papers, scan-
ners, digital cameras, clip art, page-layout and
image-editing software, reference books)

Pier 1 Imports
800–245–4595
www.pier1imports.com
(home furnishings, many ideal for Digital Decorating)

Sierra Home
800–757–7707
www.sierrahome.com
(clip art, page-layout and image-editing software)

Staples
www.staples.com
(source for home computers, inkjet printers and
papers, scanners, digital cameras, clip art, page-layout
and image-editing software, reference books)

Southworth
800–225–1839
www.southworth.com
(specialty and fine inkjet papers)

U-lead
1–800–85–ULEAD
www.ulead.com
(page-layout and image-editing software, clip-art
libraries, including many full-featured applications
and clip art for downloading free of charge)

UMAX
1–877–885–7087
www.umax.com
(scanners, digital cameras, image-editing software)

Xerox
1–800–TEAM–XRX
1–800–822–2200
www.xerox.com
(specialty inkjet printer papers, including decals;
inkjet printers, scanners)

About the Author

FROM THE FLOOR OF THE NEW YORK STOCK Exchange to articles published in magazines, newspapers, and on the Internet, Tami D. Peterson has spent twenty years telling people how to buy and use computers, first as a teacher and then as a journalist. In *Digital Decorating*, she is delighted to show so many innovative uses for the old PC. What makes her most happy is living with her husband, who is her childhood sweetheart, and their young son.

NEW AND BESTSELLING TITLES FROM

America's Best-Loved Craft & Hobby Books™

America's Best-Loved Quilt Books®

QUILTING
from That Patchwork Place®, an imprint of Martingale & Company™

Appliqué
Artful Appliqué
Colonial Appliqué
Red and Green: An Appliqué Tradition
Rose Sampler Supreme
Your Family Heritage: Projects in
 Appliqué

Baby Quilts
Appliqué for Baby
The Quilted Nursery
Quilts for Baby: Easy as ABC
More Quilts for Baby: Easy as ABC
Even More Quilts for Baby: Easy as ABC

Holiday Quilts
Easy and Fun Christmas Quilts
Favorite Christmas Quilts from That
 Patchwork Place
Paper Piece a Merry Christmas
A Snowman's Family Album Quilt
Welcome to the North Pole

Learning to Quilt
Basic Quiltmaking Techniques for:
 Borders and Bindings
 Curved Piecing
 Divided Circles
 Eight-Pointed Stars
 Hand Appliqué
 Machine Appliqué
 Strip Piecing
The Joy of Quilting
The Quilter's Handbook
Your First Quilt Book (or it should be!)

Paper Piecing
50 Fabulous Paper-Pieced Stars
A Quilter's Ark
Easy Machine Paper Piecing
Needles and Notions
Paper-Pieced Curves
Show Me How to Paper Piece

Rotary Cutting
101 Fabulous Rotary-Cut Quilts
365 Quilt Blocks a Year Perpetual
 Calendar
Fat Quarter Quilts
Lap Quilting Lives!
Quick Watercolor Quilts
Quilts from Aunt Amy
Spectacular Scraps
Time-Crunch Quilts

Small & Miniature Quilts
Bunnies By The Bay Meets Little Quilts
Celebrate! with Little Quilts
Easy Paper-Pieced Miniatures
Little Quilts All Through the House

CRAFTS
From Martingale & Company

300 Papermaking Recipes
The Art of Handmade Paper and
 Collage
The Art of Stenciling
Creepy Crafty Halloween
Gorgeous Paper Gifts
Grow Your Own Paper
Stamp with Style
Wedding Ribbonry

KNITTING
From Martingale & Company

Comforts of Home
Fair Isle Sweaters Simplified
Knit It Your Way
Simply Beautiful Sweaters
Two Sticks and a String
The Ultimate Knitter's Guide
Welcome Home: Kaffe Fassett

COLLECTOR'S COMPASS™
From Martingale & Company

20th Century Glass
'50s Decor
Barbie® Doll
Jewelry

Coming to *Collector's Compass* Spring 2001:

20th Century Dinnerware
American Coins
Movie Star Collectibles
'60s Decor